IMAGES
of America

WEST GREENWICH

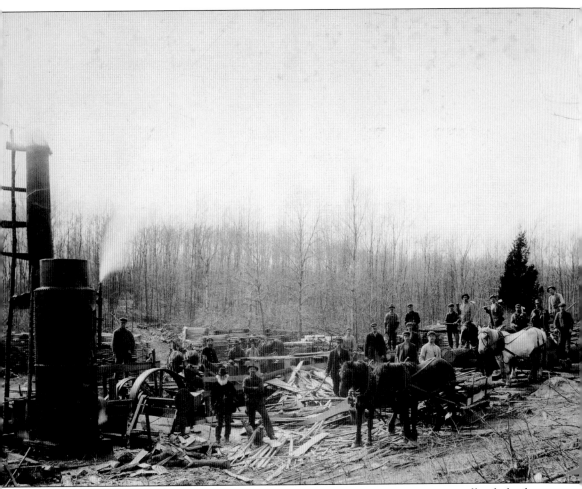

ON THE COVER: On April 1, 1913, Elmer Tarbox brought his portable steam sawmill to help clear Ben Kettelle's property in the Hopkins Hill area. Kettelle is shown front left with a white beard. Tarbox is standing next to him. Kettelle's son Samuel is behind the horse. Harry Brown is behind Kettelle, and Bernard Harrington is behind Tarbox. Others include members of local families and unidentified wood choppers. (Courtesy of Shirley Kettelle Barbour.)

IMAGES
of America

WEST GREENWICH

Kathleen A. Swann, PhD
Foreword by Kevin A. Breene

ARCADIA
PUBLISHING

Copyright © 2011 by Kathleen A. Swann
ISBN 978-0-7385-7599-5

Published by Arcadia Publishing
Charleston, South Carolina

Printed in the United States of America

Library of Congress Control Number: 2011923295

For all general information, please contact Arcadia Publishing:
Telephone 843-853-2070
Fax 843-853-0044
E-mail sales@arcadiapublishing.com
For customer service and orders:
Toll-Free 1-888-313-2665

Visit us on the Internet at www.arcadiapublishing.com

*To my West Greenwich ancestors, especially my father, Jorma Sundelin,
for teaching me to love, respect, and nurture our land and community*

P- 46

CONTENTS

FOREWORD

I am honored to write the foreword for *West Greenwich*. Living in town my entire life and being descended from many of its original founders, I have always been proud of its rural independence and unique quality of life. West Greenwich is one of the least populated communities in Rhode Island. It has a rich history of volunteerism, patriotic responsibility, and old-fashioned Yankee ingenuity. From its incorporation in 1741, when it was split off from East Greenwich, right through to today, it remains a very special place to live.

I am fortunate to have known many of the old-timers who came before me, and I enjoyed their stories of places, events, and changes in the town. From the beginning, West Greenwich has been known for its vast stands of high-quality white pine timber (locally known as "West Greenwich mahogany") and for its top-quality white oak, used in early years for shipbuilding. The demand for good lumber quickly turned the forested areas into cleared agricultural land. The town's many small brooks were dammed to provide water power for mills that sprung up throughout the town. By the late 1700s, the town's population stood at 2,500 inhabitants. However, with America's Industrial Revolution and the depletion of fertility on the many farms in town, the population shrank to 450 by the Great Depression. Abandoned farmland once again became forested, renewing an active local lumber industry. In the early 1900s, there would commonly be 25 or more sawmills operating throughout the town. Many townsmen were employed cutting logs and firewood or working on the sawmills.

The past 50 years brought many changes that affect the future of West Greenwich. The building of Interstate 95, industrial development, the formation of our regional school district and high school, and our increasing population are signs of a modern, growing town. However, our commitment to open space through preservation and conservation will perpetuate the rural quality of life that has always made West Greenwich a great place to live. I hope you will enjoy this book.

—Kevin A. Breene
West Greenwich town administrator

AKNOWLEDGMENTS

I grew up playing, hiking, and learning in the West Greenwich woods. My dear, departed family members, who guided me through those woods, instilling a respect and love for them, must be the first acknowledged. Their memory inspired this book. My father, Jorma Sundelin, my uncle William Sundelin, my great-aunt Ardis Barbour, and my great-uncle Howard Barbour patiently taught me the wonders of nature and history.

Many people helped me design and complete *West Greenwich*. Kevin Breene offered insight, experience, and ongoing help locating obscure photographs. Robert and Charlene Butler provided their research knowledge to help outline the content. Elsie Oltedale, director of the Louttit Library (also, my third grade teacher), and the library staff were friendly and helpful whenever I popped in to research their archives. Roberta Baker provided binders of photographs catalogued by the West Greenwich Historical Preservation Society. She also gave the book a final review that brought clarity and accuracy. Steven Wright of the West Greenwich Land Trust provided the connection to our community, although his work is really just starting. University of Rhode Island staff members Tom Mitchell, at the W. Alton Jones campus, and Sarina Wyant, in Special Collections, helped document the Eisenhower visits. Hilary Zusman and Lissie Cain, my editors at Arcadia Publishing, gave advice and gentle reminders as needed. My mother, Ann Sundelin, shared her background knowledge of West Greenwich, my brother Cliff Sundelin taught me about sawmills, and my brother John Sundelin had the answer to every genealogy question I threw his way. I am grateful for, indebted to, and in awe of the many people, who opened their scrapbooks and their memories to me. Their names are noted throughout the book. Last, but certainly not least, my husband, Brian Swann, acted as technical director for the book. He handled the digital imaging and went out of his way to get needed photographs. Without his inspiring and dedicated work, this book would just be a collection of words.

I thank you all. The book shows the results of your help, but your friendship and shared love for our town are in my heart.

INTRODUCTION

The history of West Greenwich is a story of land and how people interact with it. In fact, the land is an integral part of the town's identity. West Greenwich's vast forests and clear streams are sources of pride for its residents and, for many, the reason they choose to live here. Ironically, the land is not high-quality farmland, so its residents learned to be resourceful and to work hard. They were an early breed of entrepreneurs, carving a living out of beautiful land that was dominated by trees and rocks, isolated from the rest of the state. A small, tightly knit community emerged. *West Greenwich* tells the story of these people, their relationship with the land, and how they created a wonderful place to live. While the context was, and still is, shaped by changes in the outside world, the people of West Greenwich remain true to the land, focusing on preservation of open space to ensure the rural quality of life they value.

West Greenwich is located in the heart of Rhode Island. The western edge of its 51-square-mile rectangular shape borders Connecticut. Its gently rolling landscape is punctuated with several hills, one of them high enough for a local ski slope to operate from the 1960s through the 1980s. These hills were created by glacial sediment. Continental ice sheets covered the land and deposited loose, stony material. The receding glacier left sand and gravel. Granite bedrock breaks through the soil with outcroppings, boulders, and multitudes of rocks of all sizes. New stones continually surface, especially in the spring. Old-time farmers called them "New England potatoes," and West Greenwich receives an ample serving every year.

Granite and other rocks are evident on any walk or ride through West Greenwich. Huge boulders bring their imposing presence to roadsides, house lots, and farmlands, as road builders gave up trying to remove them and just built around them. Miles of stone walls crisscross the woods and fields, constructed by farmers to define their boundaries, to contain animals, and to merely get the rocks out of the way. There are curious cairns, structures built of carefully balanced rocks, dotting the woods. Legends surround these mysterious man-made structures. Some believe they have aboriginal beginnings, were constructed by Native Americans as trail markers, or reflect the humor of a past farmer frustrated with continually clearing rocks from the pastures. They are delightful surprises to see amid the reforested trees. The most impressive rock formations were not made by humans. There are several huge areas of exposed ledge, creating structures of caves and overhangs. The largest is Rattlesnake Ledge in the Wickaboxet Management Area, a jutting edifice with panoramic views of acres of woodland from its peak. Archeological research has recovered almost 500 relics from many groups of people, as early as the Archaic Period of hunter-gatherers. A similar ledge outcropping, sometimes called Witch's Rock, is near Carr's Pond in the Big River Management Area. Both sites show evidence of early inhabitants, including Narragansett Indians, who came inland for shelter during the winter. The rocky overhangs were used to support poles for lean-tos. Many artifacts (including projectile points and scrapers) have been found.

The sandy, rocky soil made farming very difficult. When English settlers started to arrive in West Greenwich, they carved homesteads out of the forests. While they maintained livestock and

gardens for personal consumption, there was little profit in farming as a business in this rugged landscape. They turned, instead, to the most plentiful resource at hand, the forests. The sandy soil and climate were perfect for trees, especially white pine. The area became known as the White Pine Belt, and local lumbermen called white pine "West Greenwich mahogany." Hardwoods, such as oak and birch, were also plentiful. Chestnut was a valuable commodity until blight wiped out the species in the early 20th century. Other wood-related products, including acid, charcoal, and witch hazel, were produced. The lumber industry grew so much that by the mid-18th century, most of West Greenwich was cleared. Granite, West Greenwich's other natural resource, was quarried by a few industrious men. However, profits were limited because there was no good method to transport the granite slabs beyond the local community. Luckily, West Greenwich had yet another abundant natural resource in its clear streams and ponds.

West Greenwich has two major streams, Big River on the eastern end and Wood River in the west. Their multiple branches and associated networks of ponds and brooks provided water power for mills throughout the town. The earliest mills were gristmills. Narragansett and Wampanoag Indians taught the English settlers to grow and grind corn, and it became a replacement for wheat, which would not grow in this area. The demand for cornmeal increased, and enterprising settlers built gristmills to feed their families and to sell for profit. White cornmeal (so delicious it was called "ambrosia") became popular for making johnnycakes, a fried cornmeal flatbread believed to have originated in Rhode Island. Innovative and frugal, the settlers soon expanded their gristmills to also serve as sawmills. Early mills were water powered, but it was difficult to transport large felled trees from the forest to the mill. With the invention of steam engines, portable sawmills could be brought to the logging site. These were eventually replaced with diesel-powered engines in the 20th century. However, most mills in West Greenwich remained water powered and they dotted the streams throughout town. Their products included cotton, yarn wool, sash cord, warp, and twine. Big River (with its feeders Nooseneck River, Fry Brook, and Raccoon Brook) provided the best water power, and several large mills were erected along Nooseneck Hill Road. They became the center of a busy village.

Transportation was an ongoing problem for the settlers in West Greenwich. It was difficult to get into the town and it was even harder to ship products out. The town's isolation was caused by its location and the lack of good road systems or public transportation. Early roads were dirt, built around the massive boulders that prevented a straight path. In 1816, a group of businessmen formed a corporation to operate a toll turnpike connecting Pawtuxet Valley with New London, Connecticut, an important leg in the journey from Providence to New York. The turnpike opened for traffic in 1821, and it created a bustling stretch of inns and taverns along its route. The only West Greenwich tollhouse on the New London Turnpike, the Webster Gate, was at the intersection with Hopkins Hill Road. Unfortunately, the turnpike business was never very profitable, and it became obsolete when a railroad station was built in nearby Coventry. The formerly busy thoroughfare became a ghost town, and the inns turned into seedy places of ill repute, dubbed "Hell's Half Acre" by a traveling minister. West Greenwich became even more isolated. Farms were abandoned and reverted to forest. In 1890, West Greenwich was rated the poorest and most desolate town in the state by the Commissioner of Industrial Statistics.

Around this time, the Nooseneck Hill area emerged as the commercial and municipal center of town, with outlying areas still farmland, homesteads, small mills, and undeveloped land. Several mills along Big River were erected, and in the 1920s, Nooseneck Hill Road was straightened and paved. This massive project coincided with the growing popularity of automobile travel. In the early 20th century, it was not unusual to see both cars and carriages parked in front of the restaurants, stores, and mills that were built along the newly paved road. West Greenwich matured as a town with growing civic engagement and government infrastructure. Public meeting spaces were built, and many social events were held. The town was booming as never before, although it was still devoid of the rapid development of the cities closer to Providence.

Just as it seemed that West Greenwich was moving in a prosperous direction, more land-related challenges stalled the growth. The state condemned land in the eastern end of town, near the

Nooseneck Hill area, to construct an interstate highway. Then, in 1966, another 8,600 acres was taken by eminent domain with the intention to build a public water supply reservoir in the Big River area. In total, 351 landowners lost their property, homes, farms, and businesses. Most of the village along Nooseneck Hill Road was taken. Some buildings were moved but many were vandalized, burned, or abandoned. About one-third of the town's land area became state property. The reservoir was never built, and the area is now a vestige of its former development. This had deep impact on the families, on the town's economic development, and on the community's heritage. The land has since been declared preserved open space, and it contributes to the distinctive rural quality of West Greenwich.

The people of West Greenwich are committed to preserving the open space, forests, and natural environment in town. The first forestation project in the state was initiated when the children of Hitty Corner School planted small trees as a school forest in 1929, sponsored by the State Department of Agriculture and the Rhode Island Forestry Association. In 1932, A. Studley Hart, president of Wickaboxet Farms, gave 270 acres to the state for forest development and experimentation. In 2006, the residents of the town approved, in an overwhelming vote, to spend $8 million to purchase and preserve land in the Tillinghast Pond Management Area. The West Greenwich Land Trust, the town's Conservation Commission, and other citizen groups strive to protect land entrusted to them. Through donated parcels, state preservation areas, and conservation purchases, approximately one-half of West Greenwich is now preserved open space. Economic development is focused along the four interstate highway exits in town.

West Greenwich has come a long way since being referred to as "vacant land" in an early deed. In 1709, the state of Rhode Island accepted a large piece of land from Ninigret, sachem of the Narragansett Indians, in payment for military defense. The parcel, including those vacant land tracts, was then purchased by a group of 13 men who divided it into parcels. As the territory grew, the people in the westernmost part petitioned the state to divide the land and create a separate town, bothered by the considerable time and trouble to travel to the eastern end for town business. West Greenwich was incorporated on April 6, 1741. It has grown into a town with more than 6,000 residents and a solid school system. Its leaders and residents struggle to maintain their commitment to the town's rural character while also creating a sustainable financial and economic base. It is a community of longtime, closely-knit families and of newcomers eager to adopt a rural lifestyle. People are involved in local sports, community groups, and politics. It is still the most heavily forested and least-densely populated municipality in the state. Residents are committed to the future of West Greenwich and its wonderful natural resources, including all those trees.

One

HARVESTING AND
HARNESSING NATURE

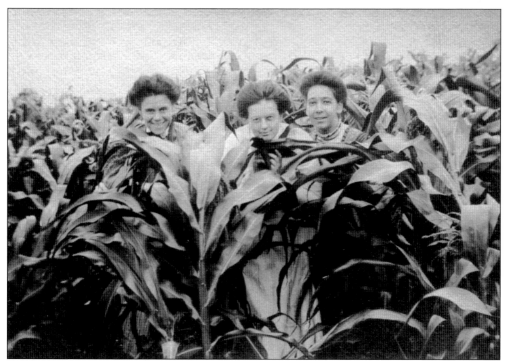

The people of West Greenwich made the most of the natural resources. They roamed the woods, fished the ponds, planted gardens, established farms, quarried granite, cut timber, and built water-powered mills. There was obviously room for fun when the work was done, as these young women hide in the cornfields in a photograph from the late 1800s or early 1900s. (Courtesy of Frederick Arnold.)

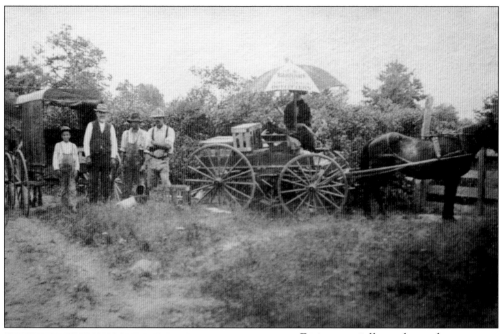

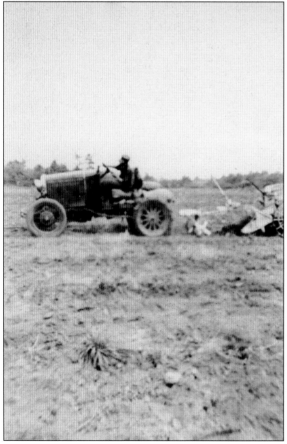

Fruit, especially apples and blueberries, was abundant. This undated photograph shows blueberries for sale at the end of Breakheart Hill Road, near the former Knight farm. These berries were picked by Frank and Louie Ballou and brought out from the fields to be sold. (Courtesy of the West Greenwich Historical Preservation Society.)

Farming was difficult in the poor, rocky soil. Early settlers relied on corn, which the Narragansett and Wampanoag Indians taught them to grow. Following the Irish immigration in the 19th century, some farmers had success growing potatoes in the loose, well-drained soil. Here, Bernard Harrington is digging potatoes while driving his uncle Norman Kettelle's tractor in a photograph taken about 1939. (Courtesy of Colleen [Harrington] Derjue.)

Hay needed to be cut, raked, dried, and stored to feed livestock over the winter. In this 1923 photograph, Clifford Joslin (right) is pitching hay onto a wagon. An unidentified man and Oliver Joslin (center) are helping to pack and secure the load. (Courtesy of the Pysz and Hoxsie families.)

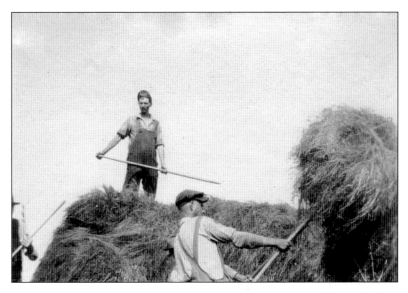

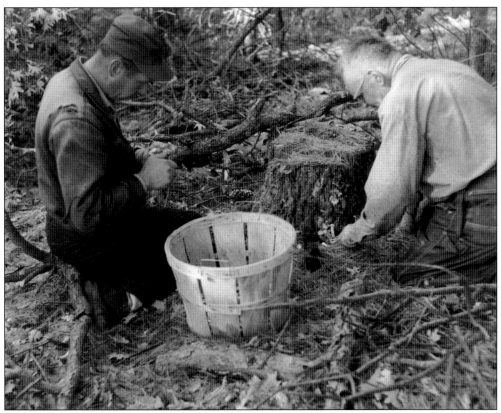

Henry Sundelin (left) and Howard Barbour are gathering mushrooms at the base of a tree stump on the Tarbox farm, probably in the mid-1960s. Mushrooms still grow wild in the West Greenwich woods, and local people know where to find the good ones. (Courtesy of John J. Sundelin.)

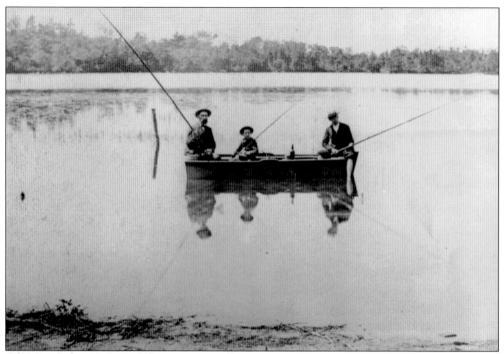

The writing on this undated photograph identifies W.L. Wood, Samuel H. Clapp, and acid factory owner Bela C. Clapp (presumably from left to right), fishing on Wickaboxet Pond. The label uses an unusual spelling, "Wickerboxett," reflecting the dialect of many Rhode Islanders. Wickaboxet's name comes from an Indian word meaning, "at the end of the small pond." (Courtesy of the West Greenwich Historical Preservation Society.)

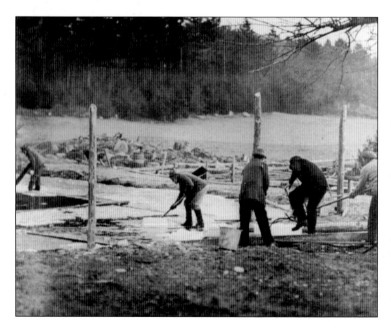

Blocks of ice were cut from the frozen ponds each winter. These blocks were stored in icehouses and retrieved as needed for refrigeration throughout the year. Sawdust was often used as insulation between the layers of ice. The men in this undated photograph are working on the Charles Brown farm, off Plain Meeting House Road. (Courtesy of the West Greenwich Historical Preservation Society.)

Deer were hunted throughout the town's history. Both the Narragansett Indians, who came inland during the winter, and the early settlers relied on venison in their diets. Deer are still plentiful, and residents continue to hunt. Frank Lemaire, who lived on Congdon Mill Road, shows off a doe in about 1948. (Courtesy of the Lemaire family.)

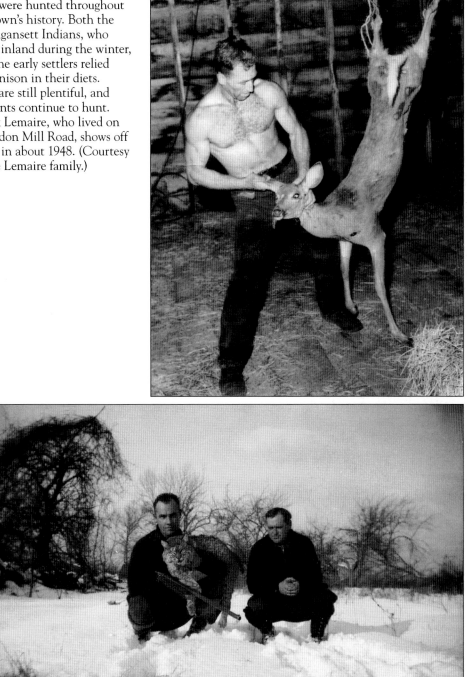

Hunters also set snares to trap animals for meat, for their pelts, or to eliminate predators stalking their farm animals. This bobcat was caught in a snare line set to catch foxes that were attacking chickens in a farm on Hopkins Hill. Surprised trappers Harris Havens (left) and Howard Barbour posed for this undated photograph. (Courtesy of John J. Sundelin.)

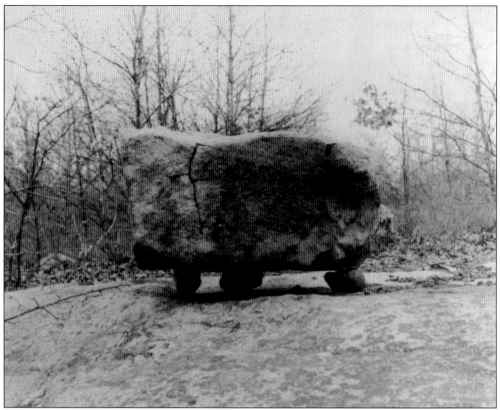

Some of the interesting rock formations in West Greenwich must have been assembled by humans. Numerous stone cairns dot the woods and former fields. The strange boulder in this undated photograph is balanced on three bowling ball–sized stones that are arranged in a triangle. Its history and purpose are unknown but can still be found in the Wickaboxet Management Area. (Courtesy of the West Greenwich Historical Preservation Society.)

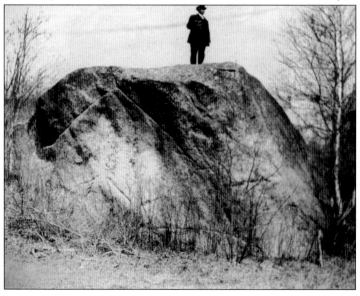

The presence of granite dominated the landscape and the lives of early West Greenwich residents. This giant boulder is on the side of Weaver Hill Road. Searles Capwell, a successful businessman, landowner, and politician, is standing on the boulder in this undated photograph, perhaps surveying his farmland. (Courtesy of the West Greenwich Historical Preservation Society.)

Sometimes a boulder dominated the landscape. This photograph of Devil's Rock was taken on the D. Robbins farm, formerly the old Benoni Matteson place. It is now part of the University of Rhode Island's W. Alton Jones Campus. Note the man with the plumed hat and sword standing on top of the rock, who also appears in photographs on pages 51 and 55. (Courtesy of the West Greenwich Historical Preservation Society.)

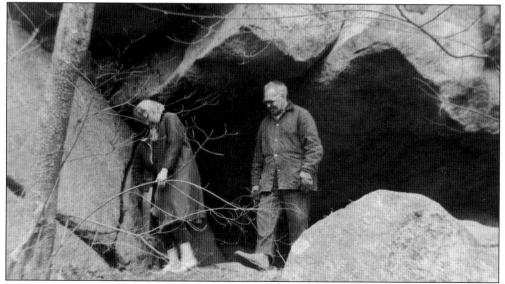

This large granite ledge, located between Carr's Pond and Tarbox Pond, has been called Witch's Rock and Indian Rocks. It is now in the Big River Management Area. Howard Barbour (right), who owned the property at the time, is showing the caves to Mrs. LeClair, a family friend. The photograph was taken in the early 1960s, before the State of Rhode Island condemned the land. (Courtesy of Clifton M. Sundelin.)

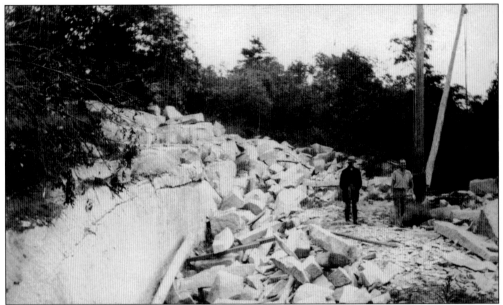

Granite ledges created by the receding glacier created another natural resource, and several quarries were established in West Greenwich. The stone was used as steps, for building foundations and walls, for millstones, and as cemetery markers. In the photograph, Oscar (left) and John Tarbox are shown in the Tarbox quarry, located near Carr's Pond, not far from the Indian Rocks pictured on page 17. (Courtesy of John J. Sundelin.)

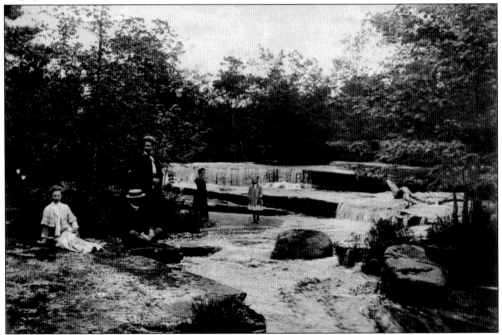

Stepstone Falls is located in Escoheag and is part of the Arcadia Management Area. The falls drop 10 feet over a distance of about 100 feet—with the tallest drop about three feet—over natural bedrock and quarried slabs. It is sometimes referred to as "Little Niagara." A family enjoys the falls in this photograph, probably from the early 1900s. (Courtesy of Russell M. Franklin.)

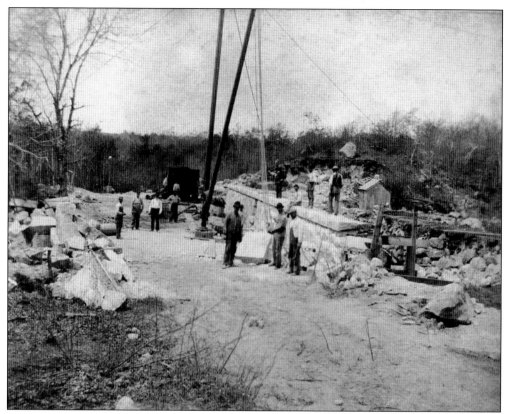

Ownership and control of water is an ongoing issue in West Greenwich. The abundant, clear water in Carr's Pond was transported to more populated areas of the state through a dam and pipeline system. The long, low earthen dam has a granite wall on the downstream face. The photograph above shows the granite wall under construction. A pipeline system built on piers, shown below, carries water from the pump house to the gatehouse. Neither photograph is dated, but state reports document the system being in place before 1946. (Above, courtesy of the Pysz and Hoxsie families; below, courtesy of the West Greenwich Historical Preservation Society.)

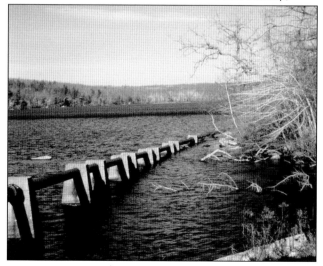

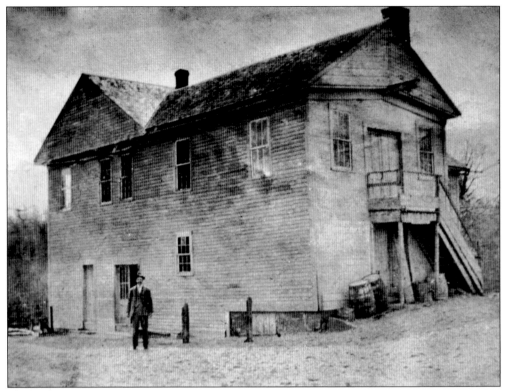

The Nooseneck Mill or Nooseneck Valley Mill stood on the west side of Nooseneck Valley, on Nooseneck Hill Road. It was powered by water from the Fry and Raccoon Brooks, which feed into Big River. The mill housed a gristmill and waterwheels that operated a spinning mill. Later, John Edwards opened a store in the lower level, subsequently operated by Jim Fish. The West Greenwich Town Council and the Nooseneck Rod and Gun Club met in the upper level. Annual financial town meetings were sometimes held in the rear room of the street floor. The mill was destroyed as part of the Big River Reservoir project. These photographs show the mill from two angles. Although they are undated, the upper photograph appears to have been taken earlier than the bottom image. (Both courtesy of West Greenwich Historical Preservation Society.)

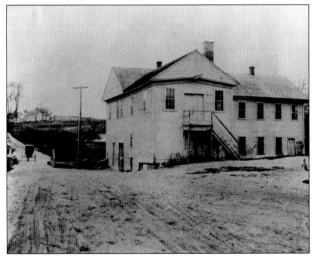

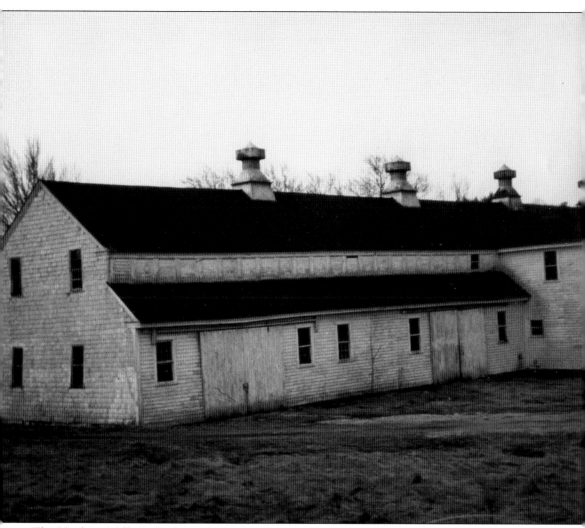

The Hopkins Mill was built in about 1867 by David Hopkins, a businessman and politician who owned several mills and many houses in the Nooseneck Hill area. It was located on the Nooseneck River, at the foot of the valley. It was considered a significant example of small, rural mill construction and is listed in the National Register of Historic Places. The one-story wooden frame mill featured a continuous clerestory monitor and stair and water closet towers. Originally built as a yarn and cord mill, manufacturing stopped in 1906. It was later used as a cattle barn and then for storage. The mill was acquired by the State of Rhode Island in 1968 as part of the Big River Reservoir project, and it was slated for demolition. Attempts were made to save the mill by relocating it to Sturbridge Village in Massachusetts. These efforts were unsuccessful, and the mill is no longer standing. Remains of the foundation and raceway are evident amid the brush growing on the site. (Courtesy of West Greenwich Historical Preservation Society.)

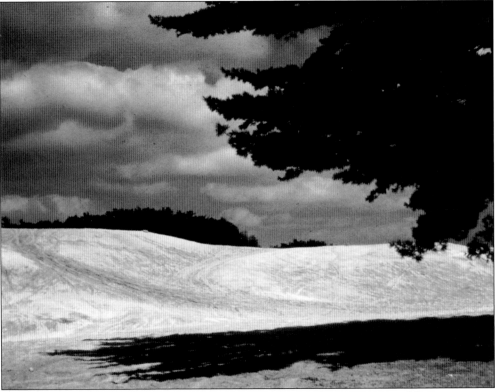

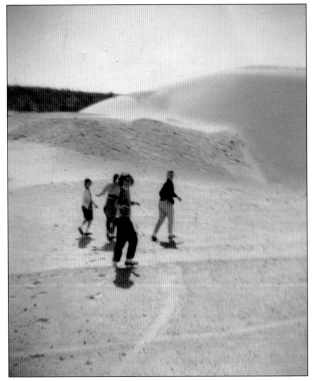

A vast expanse of deep sugary sand, known locally as "the dunes" or "the Rhode Island desert," is along Division Road in the eastern end of town, shown in the above photograph. The Albro family sold the sand to the Whitehead Brothers in New York, who shipped it to New York to produce foundry castings. The project lasted for several years until a cheaper, synthetic material was invented. The dunes are now owned by the State of Rhode Island as part of the Big River Reservoir project. It is a favorite location for sledding and hiking, as shown by these children in October 1960. Beverly Franklin Grundy snapped this photograph of Judy Andrews, Kathleen Meehan, and other unidentified friends. (Above, courtesy of West Greenwich Historical Preservation Society; left, courtesy of Russell M. Franklin.)

Two

LOGGING AND LUMBER

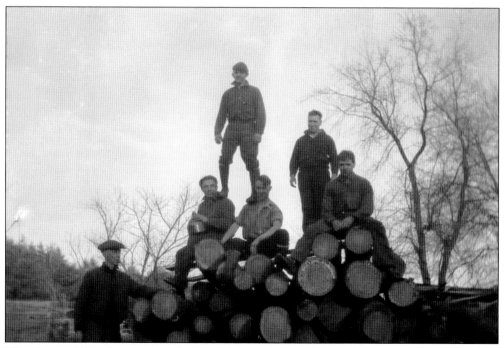

West Greenwich is the most heavily forested town in Rhode Island. Lumber was the town's major industry, starting with woodchoppers and expanding when sawmills were first built around 1740. In this 1928 photograph, Wallace Spink is on the left, and Howard Barbour is second from the left. The others are not identified. The men are posed on logs ready for the Tarbox and Hopkins sawmill. (Courtesy of John J. Sundelin.)

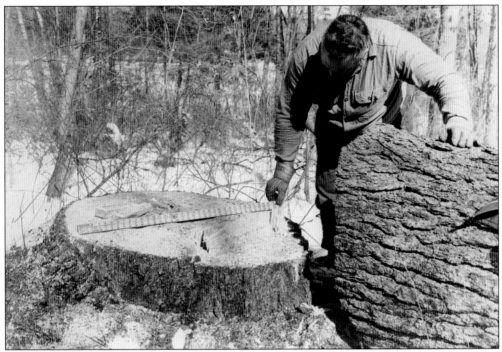

Extensive forests of white pine grow in the light, sandy soil, earning West Greenwich the designation "White Pine Belt." This photograph, taken in the early 1960s, shows Howard Barbour using a Biltmore stick to measure the diameter of a recently felled white pine tree. This measurement tool provides the logger with a rough estimate of the board feet yield of a tree. (Courtesy of Clifton M. Sundelin.)

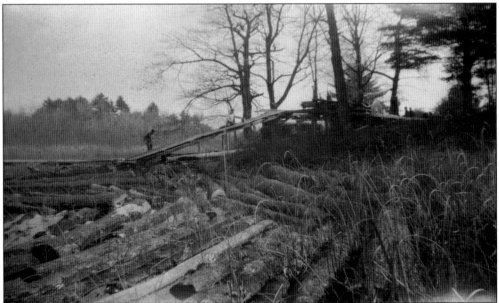

After a tree is cut down, it must be transported to the sawmill. This 1930s photograph shows a log chute at the Tarbox and Hopkins farm. Logs were dragged by a horse to the log chute and then rolled onto the chute to slide into the millpond. The unidentified man is repairing the chute. (Courtesy of John J. Sundelin.)

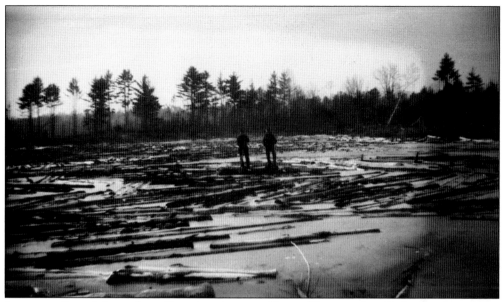

Logs were floated down the millpond to the sawmill site. These unidentified men are standing on logs in Tarbox Pond (formerly Potter Sawmill Pond). This photograph may have been taken following the devastating 1938 hurricane. Thousands of acres of downed trees had to be collected and sawed before insect borers rendered the lumber worthless. (Courtesy of John J. Sundelin.)

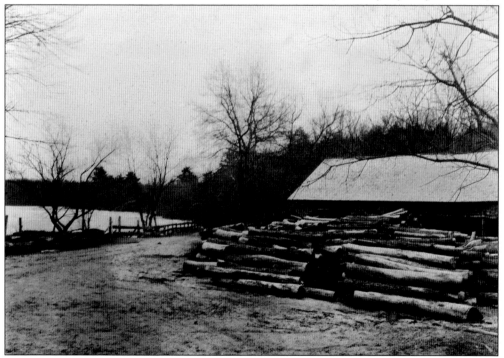

The logs were piled outside of the sawmill, ready for sawing. This rare photograph shows the Tarbox and Hopkins sawmill in the early 1930s. One of the first sawmills in America, it was built in 1740 by Pasco Coon. When this mill burned in 1935, Elmer Tarbox and Clinton Hopkins built a mill across the road and continued in business for many years. (Courtesy of Clifton M. Sundelin.)

Many local mills operated as both gristmills and sawmills. This 1910 advertising sign encouraged people to bring their corn to the Tarbox and Hopkins sawmill. It claimed the best johnnycake meal in the state. Johnnycakes are fried cornmeal flat breads, believed to have originated in Rhode Island. (Courtesy of Clifton M. Sundelin.)

Each log going through the sawmill must produce the maximum number of high-quality boards. The sawyer made quick decisions about the sequence of cuts for each log. This diagram from a 1952 sawmill operator's manual shows optimum yield for a log with knots on the sides. The log would be turned for each subsequent pass through the saw. (Courtesy of John J. Sundelin.)

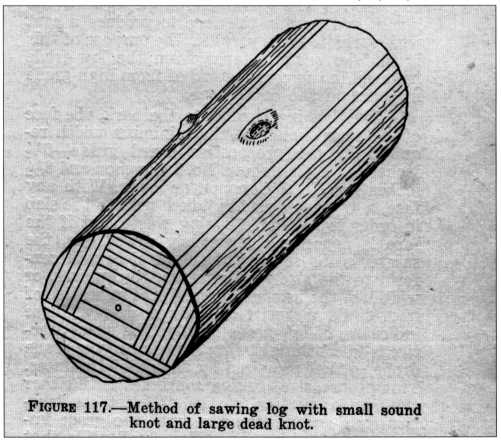

FIGURE 117.—Method of sawing log with small sound knot and large dead knot.

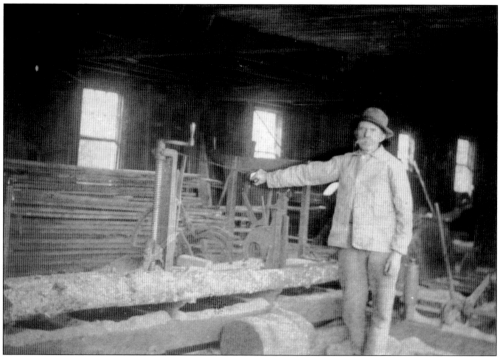

Alanson Albro ran this water-powered sawmill on Burnt Sawmill Road, photographed around 1900. He managed the sawmill operations of his father-in-law Searles Capwell's business. Albro, who directed the sawing process, was known as an excellent sawyer. The mill was on land now owned by the State of Rhode Island as part of the Big River Reservoir project. It no longer exists. (Courtesy of Kevin A. Breene.)

Bernard and Donald Harrington operated this sawmill on Henry Brown Road. The brothers earned a reputation for introducing modern techniques. The new hydraulic log turner they purchased in the 1960s attracted visitors from all over the region. The mill, shown in this 1970s photograph, still stands on family land, although it ceased operation in 2001. (Courtesy of Colleen [Harrington] Derjue.)

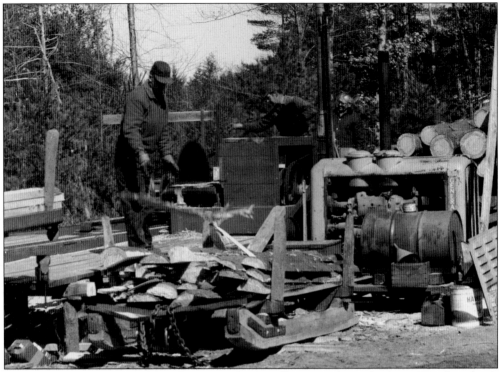

Modern machinery increased the efficiency and safety of logging. Above, this late-1950s photograph shows the three-man team needed to operate a sawmill. Howard Barbour (right) is making decisions about which logs to cut and then rolling them onto the carriage. Henry Sundelin (center) is monitoring the saw. The tube beside him is removing sawdust. A man assumed to be Elmer Tarbox (left) is tossing the slabs onto the pile. A General Motors diesel engine replaced the steampower and waterpower of earlier mills. In the 1960s photograph below, a Caterpillar D4 track-type tractor is pulling the sled (also called a skid). Horses and oxen were no longer needed. Barbour (left) and Sundelin are loading white pine logs. The sawmill can be seen in the distance, behind Sundelin. (Both courtesy of Dorothy Barbour Sundelin.)

Henry Sundelin is sharpening a saw blade in this early 1960s photograph. The 48-inch blade used on the mill in the prior photograph has removable teeth. Sundelin could touch up, repair, or sharpen the saw while it remained in place on the mill. He is using a file with his right hand. (Courtesy of Dorothy Barbour Sundelin.)

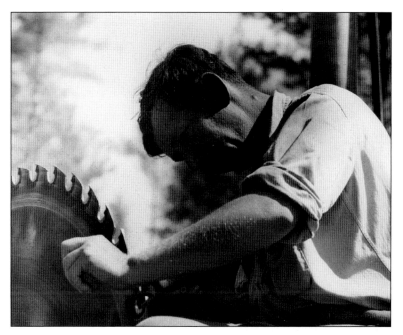

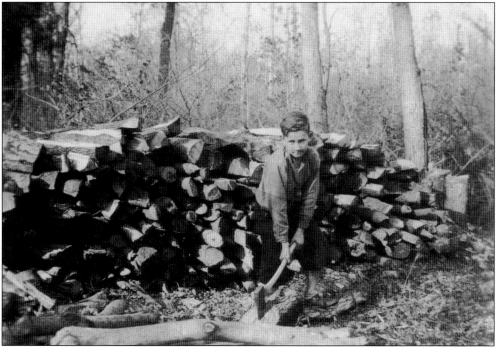

Loggers learned their skills by working alongside veteran woodsmen, then by getting out and doing the work. This photograph, probably taken in the early 1930s, shows a young Russell Franklin splitting wood. The logs were already cut to length, and his job was to split each log into halves or quarters so it would burn better in a woodstove. (Courtesy of Russell M. Franklin.)

This is the Tarbox and Hopkins sawmill, sawing pine in the woods near Carr's Pond, in about 1960. Henry Sundelin (right) was the sawyer, and Howard Barbour received and tallied the boards as they came off the carriage. A blower underneath the saw sent the sawdust out a long pipe, away from the mill and the workers. (Courtesy of Clifton M. Sundelin.)

The sawn boards are stacked in the lumberyard for drying in this photograph from the late 1940s. Henry Sundelin (left) is unloading boards as Howard Barbour carries one to the pile. These boards are box piled with stickers (spacers) of the same lumber between the tiers. This method is recommended for hardwoods, and it saves yard space. (Courtesy of John J. Sundelin.)

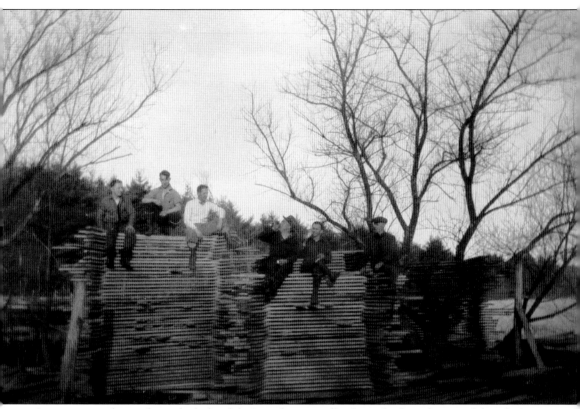

It is great to relax at the end of a hard day's work, especially if you climb to the top of that day's production and enjoy some refreshment from a jug. This 1928 photograph shows workers at the Tarbox and Hopkins sawmill. Wallace Spink is far right and Howard Barbour is third from the right, with the jug. The boards, probably white pine, are stacked using crib piling, in which tiers are formed in a triangle to promote drying. All piles needed to be closely monitored for warping, cracking, and staining. There were many jobs in the logging industry during its heyday. Cordwood choppers worked independently to clear land and cut the logs to the standard four-foot length. Loggers worked in two-man teams, felling larger trees for mill sawing. Teamsters got the logs out of the woods and to the mill. The abundant trees in West Greenwich kept woodsmen busy for many years. The trees also provided the natural resources for other products, including acid and charcoal. (Courtesy of John J. Sundelin.)

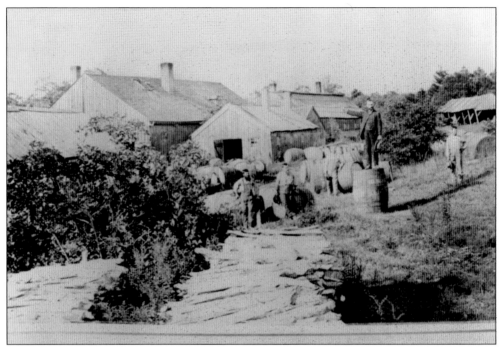

The Bela P. Clapp and Company acid factory operated in the Escoheag area around 1866 to 1883. It distilled wood fibers into the pyroligneous acid used by textile manufacturers all over New England to produce dyes. At its peak, the Clapp factory produced 800 gallons of acid each day. The buildings all burned in the great forest fire of 1907. (Courtesy of West Greenwich Historical Preservation Society.)

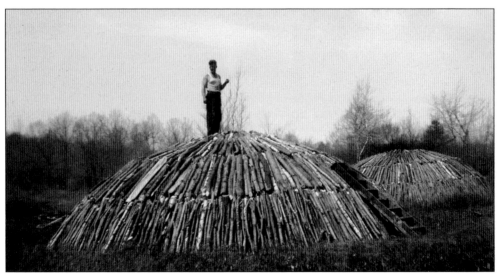

Charcoal pits turned wood into charcoal. Layers of wood, hay, and earth were mounded about ten feet high and twenty feet in diameter, with openings at ground level to ignite the wood. The pit was watched continually for about a week to be sure the wood only smoldered, creating charcoal. This undated photograph shows an unidentified man standing atop one of several charcoal pits. (Courtesy of John J. Sundelin.)

Three

HOMESTEADS AND FARMS

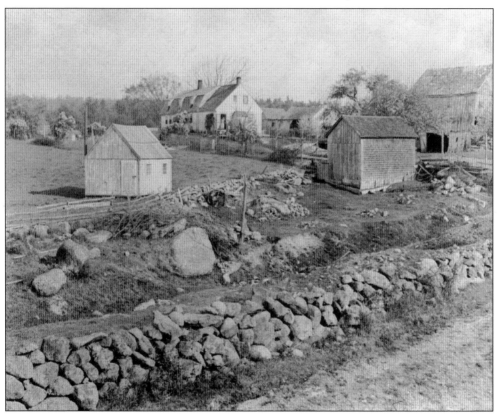

The Charles Brown farm was on Plain Meeting House Road. This undated photograph provides an overview of a rural homestead. The house is surrounded by multiple outbuildings, barns, and several types of fences. The process of clearing rocks from a field is clearly illustrated through the progression of clear pasture, piles of rocks sorted by size, and a resulting stone wall in the foreground. (Courtesy of West Greenwich Historical Preservation Society.)

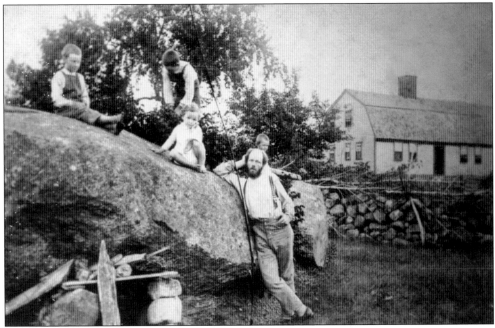

This photograph of the Brown family posed on one of their rocks includes, from left to right, Fred Brown, Stephen Brown, Clifford Brown (seated, in a white dress), Charles Brown (standing), and Pardon Brown behind him. This image is from a glass plate, similar to those used by photographers of the Civil War period. Note the visible crack in the plate. (Courtesy of West Greenwich Historical Preservation Society.)

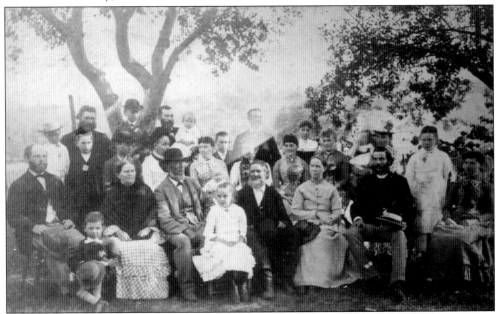

Members of the Brown family gathered at the home of Ambrose Brown of Nooseneck Hill for this photograph taken about July 1886. Brown is in the front row, near the center, with a full beard. Notice the Brown family members from the prior photograph, including Charles Brown and his little boy Pardon. (Courtesy of West Greenwich Historical Preservation Society.)

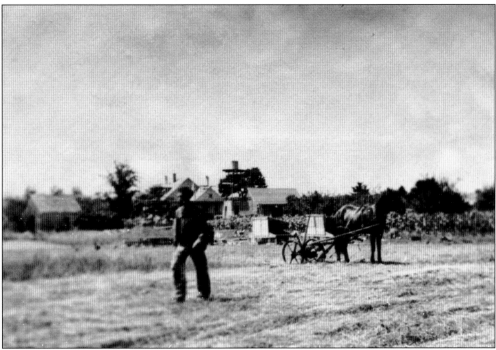

Pardon Tillinghast Brown is working the fields at his farm off Liberty Hill Road in this photograph taken on August 26, 1918. The farm buildings are clustered close together and dominated by a large water tower. Brown appears to be cutting hay and is wearing "bibbers," the preferred clothing of many farmers and loggers. (Courtesy of West Greenwich Historical Preservation Society.)

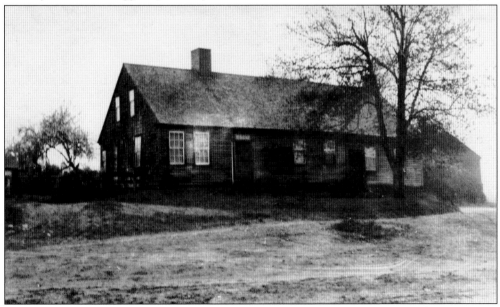

The J.A. Greene house and store stood on the corner of Victory Highway and Sharpe Street. It was known for its "rum wall," still evident on the property. Customers unable to pay for their rum could settle their bill by building a few feet of the large wall behind the house. A new house has been built on the old foundation. (Courtesy of West Greenwich Historical Preservation Society.)

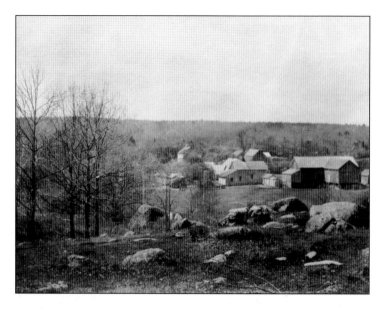

Searles Capwell was the largest lumber dealer in the region. He owned multiple properties and businesses in West Greenwich and in Coventry. His home was at the foot of Weaver Hill. This undated photograph gives an overview of the farm and its landscape. The house is visible in the background. (Courtesy of West Greenwich Historical Preservation Society.)

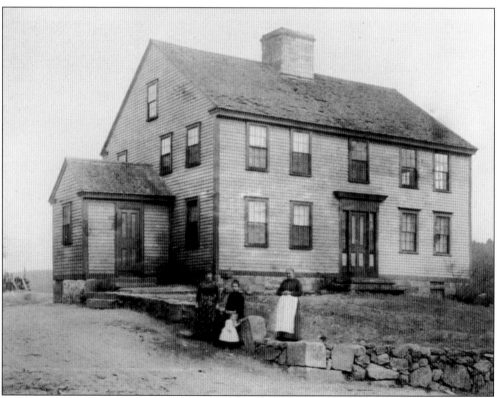

Searles Capwell's home, shown in 1894, reflected his business success. He expanded into Coventry and opened Capwell Lumber Company. Capwell designed and built homes, and his company sold all the building materials. He eventually built a luxurious home in Coventry and lived there in his later years. He served as a state senator from West Greenwich and from Coventry. (Courtesy of West Greenwich Historical Preservation Society.)

Searles Capwell owned many properties, including this farm on the west end of Division Road. It is said he purchased several tracts of land in an effort to create a viable path for transporting his lumber and sawmill products out of West Greenwich. This photograph, from about 1895–1900, shows his daughter Evangeline (Eva) and her husband, Alanson Albro, who later owned the farm. (Courtesy of West Greenwich Historical Preservation Society.)

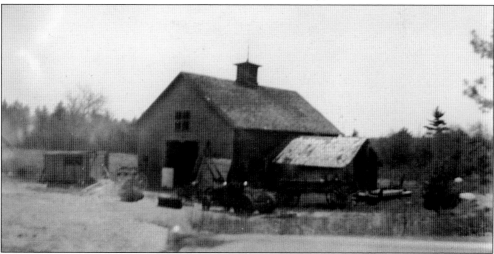

This barn is part of Searle Capwell's farm on Division Road. For many years, it was the Albro farm. Roberta Baker lived there as a young girl, and she remembers playing in the old barn, hiding notes under the loose shingles. The property was condemned by the state as part of the Big River Reservoir project. The buildings no longer stand. (Courtesy of Gloria Albro Silverman.)

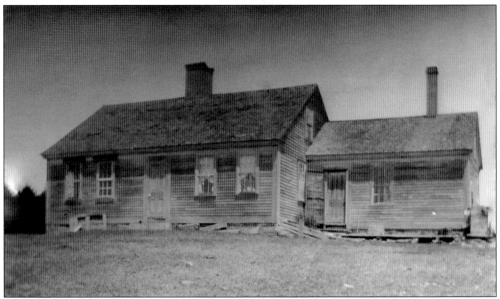

The William Whitford house was built on Burnt Sawmill Road about 1770. It was later owned by Alanson Albro. It was purchased by Kenneth Breene in 1952. The house was remodeled and moved to Mishnock Road after being condemned in the Big River Reservoir project. (Courtesy of Kevin A. Breene.)

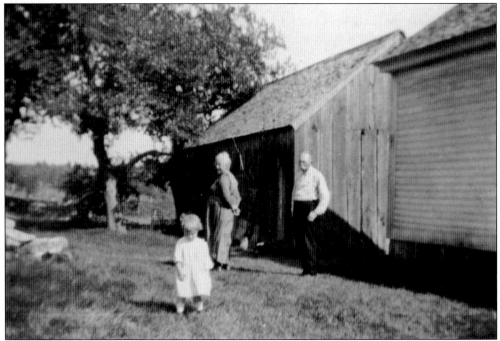

Alanson and Eva Albro are keeping an eye on their granddaughter Carolyn Albro Breene in the farmyard of the William Whitford house. Albro family members were very involved in the community, politics, and public service. Both Eva and Alanson served in elected office, along with many other Albros. Carolyn was instrumental in establishing Kent County Memorial Hospital. (Courtesy of Kevin A. Breene.)

The Metcalf cottage on Congdon Mill Road was built in the late 1880s and is shown in a recent photograph. Extensive landowners, the Metcalf family donated land to the town for schools and a fire station. The Andrews family lived in this house as caretakers. The house was condemned in the Big River Reservoir project and has been demolished. (Courtesy of West Greenwich Historical Preservation Society.)

The Spencer Greene place, built about 1750–1760, sits close to Nooseneck Hill Road. This photograph is from the 1970s. Members of the Albro family have been living there, but the house and land were condemned as part of the Big River Reservoir project. (Courtesy of West Greenwich Historical Preservation Society.)

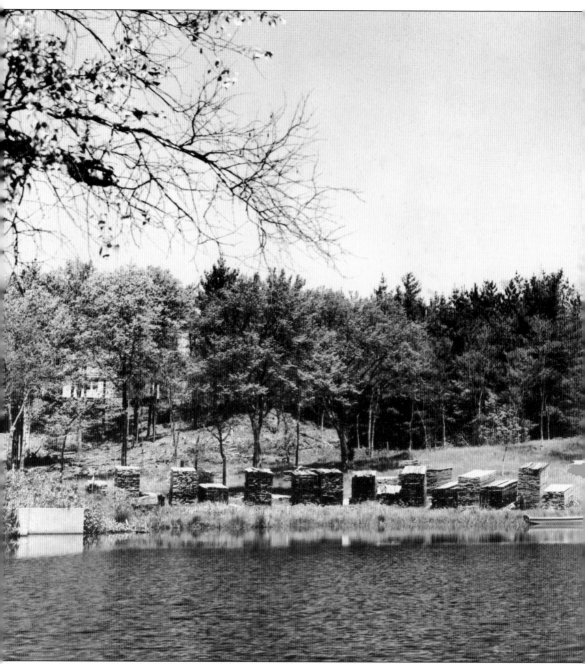

This Tarbox farm photograph was taken in the early 1960s. The farmhouse was vacant, but the Tarbox and Hopkins sawmill was still operating on the property. Its homestead and sawmill businesses were originally owned by Charles Potter in the 1880s. The 30-acre body of water in the foreground was created when the dam at Carr's Pond was raised. Elmer Tarbox and Clinton Hopkins took over the farm and the gristmill and sawmill businesses. The approximately 600 acres

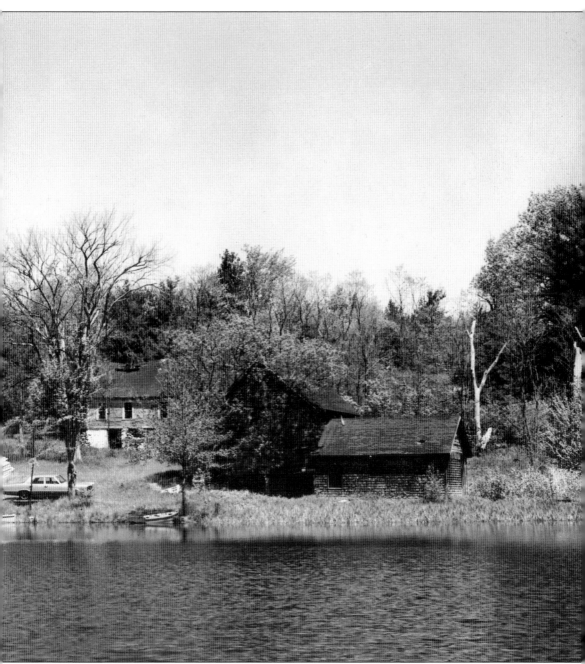

of land were used for logging, farming, and haying. The original dam was replaced in 1949, and a stray rock from the blasting punctured the roof of the barn, on the far right. About that time, Howard Barbour took over the family business. The Barbour Lumber Company continued on this site until the state condemned the entire property as part of the Big River Reservoir project. (Courtesy of Clifton M. Sundelin.)

This undated photograph shows the Tarbox farmhouse while it was still occupied. Elmer Tarbox raised his family in this house. It overlooked Tarbox Pond and was across the road from the Tarbox and Hopkins sawmill and gristmill. The house is gone, but the foundation remains as part of the Big River Management Area. (Courtesy of the Maguire family.)

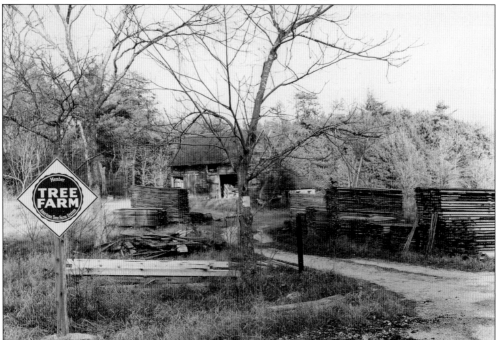

These pine boards are stacked for drying at the Barbour Lumber Company in the early 1960s. Howard Barbour's company earned certification through the American Tree Farm System for upholding the highest standards for family forest landowners. This photograph was taken shortly before the state condemned the property as part of the Big River Reservoir project. (Courtesy of Dorothy Barbour Sundelin.)

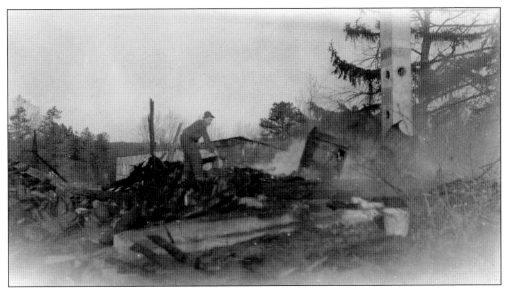

The Lemaire family owned a farm on Congdon Mill Road. They operated a logging business, sawmill, greenhouse, and farm. The house burned in 1939. This photograph shows Frank Gelinas, a family friend, raking through the rubble for anything salvageable. Fires were always a threat in the heavily forested town, but losing a home was especially tragic. (Courtesy of the Lemaire family.)

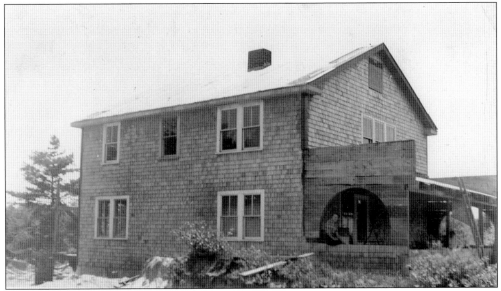

The Lemaire family rebuilt their home over the next two years, using the fire as an opportunity to build on a new location, further up the hill. This photograph shows the new home, nearly completed with a large porch on the right. The property and home were condemned by the state in 1966, as part of the Big River Reservoir project. (Courtesy of the Lemaire family.)

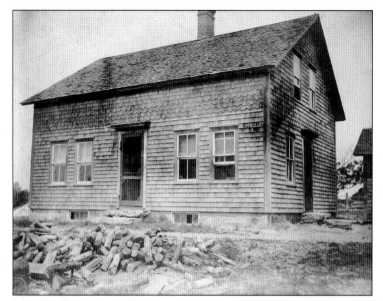

Ben Kettelle's house on Hopkins Hill Road is shown in this photograph from about 1900. This book's cover photograph shows more land being cleared on the farm, about one-half mile into the woods from this house. It was also the home of Kettelle's son, Samuel, when he was town treasurer. (Courtesy of Colleen [Harrington] Derjue.)

A photograph from the 1920s shows the barn on Kettelle's farm, which was later owned by the Harrington family. During World War II, the property was condemned by the US Navy for use as a training facility. In 1942, an airplane crashed nearby, killing five crewmen. The land was eventually returned to the owners, but the buildings and fields were severely damaged. (Courtesy of Colleen [Harrington] Derjue.)

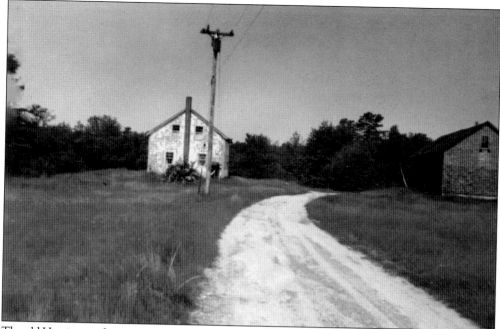

The old Harrington farm, pictured in this 1955 photograph, sits off Victory Highway. It was purchased by Kevin Breene to use as a dairy farm. Breene has served as president of the West Greenwich Town Council, a state senator, and is the West Greenwich town administrator. Breene Hollow Farm is one of the few dairy farms still operating in the state. (Courtesy of Kevin A. Breene.)

The Jeremiah Matteson house is a large double house, listed in historical documents as built in 1812. However, a plaque in the house identifies at least a portion that may be have been built in 1774. Matteson was a local blacksmith. This photograph was taken in April 1958. (Courtesy of Colleen and Gary Studley.)

The Kitt Matteson Tavern, built about 1740, is on Kitt's Corner, near Weaver Hill Road and Nooseneck Hill Road. It became a tavern in 1780 and was later the home of town clerk Erving Matteson. Matteson is shown on page 97, standing in the office he built near the house to conduct town business. The house has been beautifully restored, as shown in this 1975 photograph. (Courtesy of West Greenwich Historical Preservation Society.)

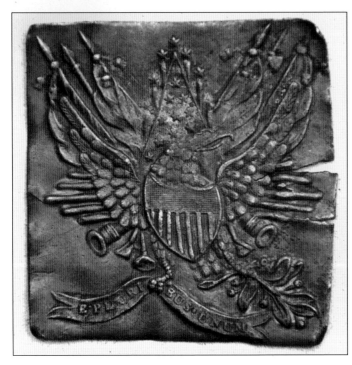

This historic war medallion was discovered in an old barn at the Squire Oliver Matteson house on Weaver Hill Road. Lt. Oliver Matteson served in 1st Company, West Greenwich Militia. Experts determined this is a rare US Militia belt plate, probably dating between 1810 and 1830. The Matteson house was built in the 1770s and expanded in the mid-1800s. (Courtesy of the Pysz and Hoxsie families.)

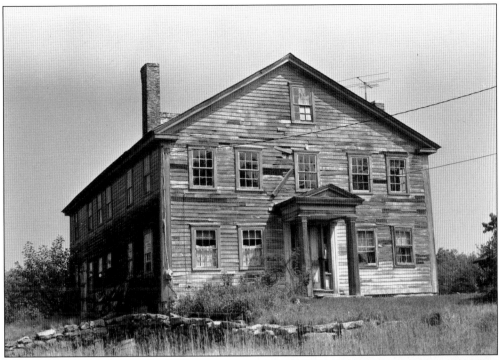

This photograph, taken in the 1970s, shows the Squire Oliver Matteson house's Greek Revival elements, including an unusual five-bay gable entry. It was the boyhood home of judge Elmer Rathbun, who served as chief justice of the Superior Court. Unfortunately, the house burned to the ground in 1986, before the owners could begin renovation plans. (Courtesy of Pysz and Hoxsie families.)

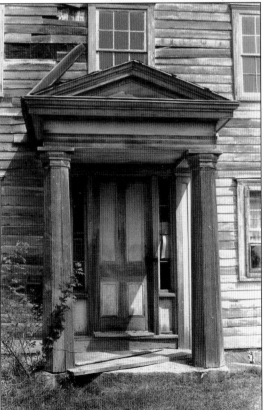

The elegant pedimented portico with eight-sided tapered columns dominated the front facade of the house, shown here in another 1970s photograph. Before the fire, the house had been nominated to appear in the National Register of Historic Places. The Pysz family rebuilt the house on the same footprint in 1988. (Courtesy of the Pysz and Hoxsie families.)

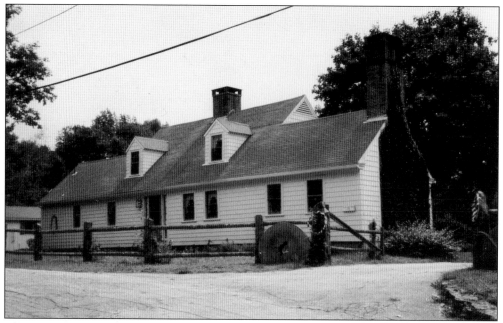

The Peleg Matteson house on Plain Meeting House Road was built about 1790. This recent photograph shows its center chimney and side additions. The house contains three original fireplaces, a beehive oven, and a smoke chamber. Matteson purchased the property in 1831 and it was later owned by the Louttits. It has been renovated and is now called Millstone Farm. (Courtesy of West Greenwich Historical Preservation Society.)

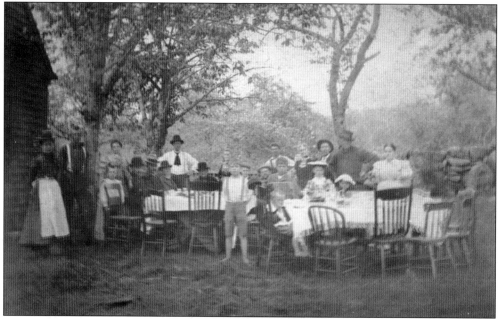

Family and friends are enjoying a clambake in the yard of the Peleg Matteson farm, when it was known as the Henry Corbin place. The photograph is undated, but people around the table are listed on the back. Family names include Horton, Knight, Sweet, and Rathbun. (Courtesy of West Greenwich Historical Preservation Society.)

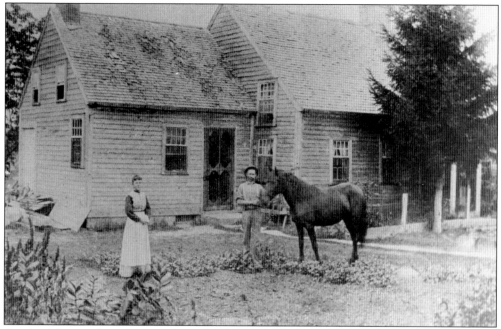

Another Matteson farm, shown in this undated photograph, was known as the poor farm. The Matteson family occasionally provided temporary housing and work for local people who were down on their luck. The property was purchased by William Easton Louttit in the early 1930s as part of his country estate called Hianloland Farms. (Courtesy of West Greenwich Historical Preservation Society.)

Louttit's 3,000-acre purchase included many old historic farms, including several from the Matteson family. The poor farm, pictured above, became son William Easton Louttit Jr.'s house. This undated photograph shows its 20th century renovation, which included an illuminated spring-fed swimming pool in the backyard. The house has since burned. (Courtesy of West Greenwich Historical Preservation Society.)

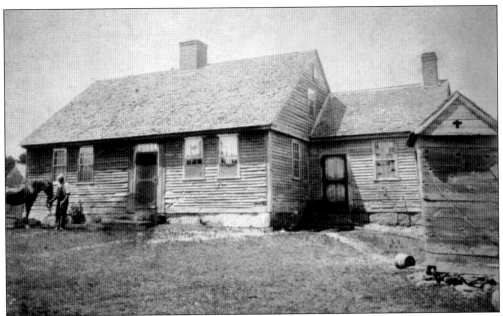

The Parker house is a Greek Revival farmhouse built about 1830. This old, undated photograph shows an unidentified person with a horse on the left. The property was purchased by William Easton Louttit in the early 1930s, as part of Hianloland Farms. The Louttit family sold Hianloland Farms to W. Alton Jones in 1955. (Courtesy of West Greenwich Historical Preservation Society.)

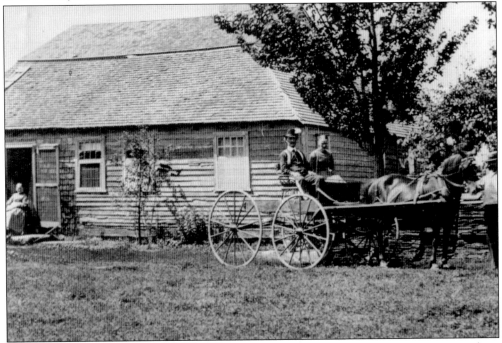

The Bowen Matteson farm, shown in this undated photograph, was included in the Louttit purchase and later sold to W. Alton Jones in 1955. The entire property was donated to the University of Rhode Island upon Jones's death. A youth education center is now where the Bowen Matteson farm was located. (Courtesy of West Greenwich Historical Preservation Society.)

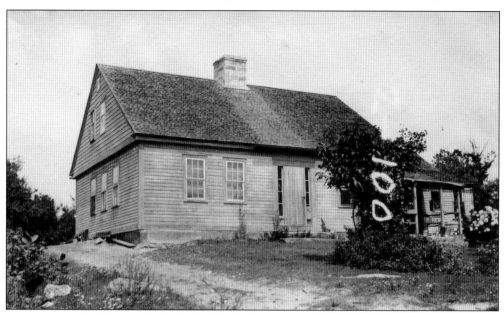

This photograph of the Benoni Matteson house was taken in August 1916. Matteson was a blacksmith and ironmonger. He and his family raised or produced just about everything they needed on their farm. Matteson was known as a jack-of-all-trades and earned money by producing iron products in his blacksmith shop. (Courtesy of West Greenwich Historical Preservation Society.)

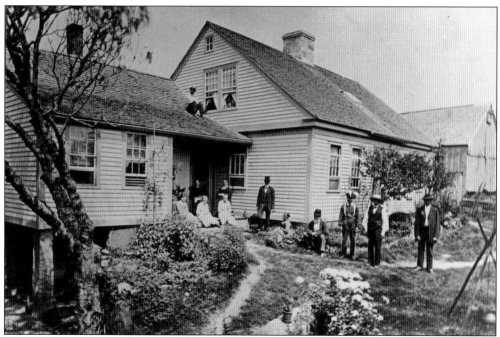

This undated photograph shows the Benoni Matteson house following significant additions and renovation. One brave fellow is perched on the roof. Note the sword and plumed hat on the gentleman third from the right. He may be the same man standing on Devil's Rock on page 17 and in the barn on page 55. (Courtesy of West Greenwich Historical Preservation Society.)

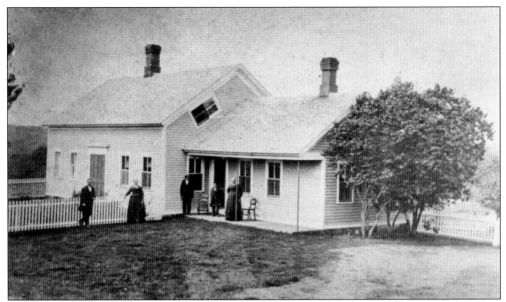

The Jeremiah Matteson farm is pictured in this undated photograph. Matteson had five sons who were active in the Civil War, including one who was killed. The house, with its interesting window on the second floor, is still standing. It is part of Woodvale Farm on the W. Alton Jones Campus of the University of Rhode Island. (Courtesy of West Greenwich Historical Preservation Society.)

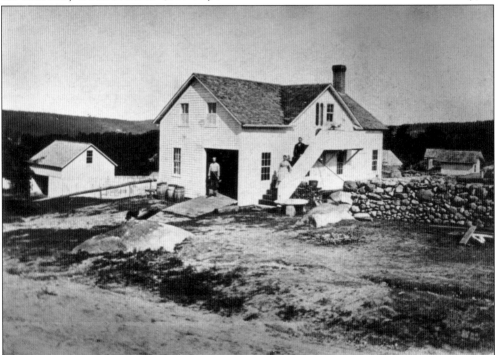

The Jeremiah Matteson farm had several outbuildings, including this blacksmith shop. The shop had an ox sling used to support the ox while it was being shod. Matteson is standing in the shop's doorway in this undated photograph. The people on the stairs are not identified. (Courtesy of West Greenwich Historical Preservation Society.)

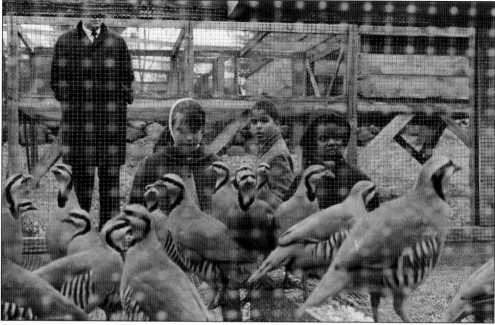

Game birds were raised on Hianloland Farms when it was owned by the Louttit and Jones families. When the University of Rhode Island received the property as a donation from the Jones estate, it continued to raise game birds for several years. Children visiting the education center on the campus could see the game birds, as shown in this 1968 photograph. (Courtesy of University of Rhode Island archives.)

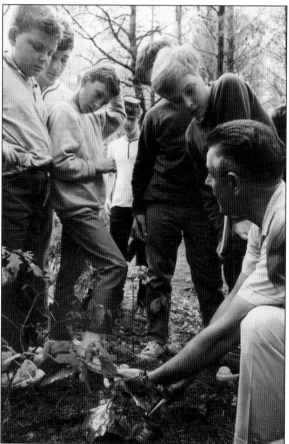

The University of Rhode Island created an environmental education center, research facility, and conference center on the W. Alton Jones Campus. Children are learning about plant science in this 1968 photograph of the Project Earth initiative on the campus. School groups, youth organizations, and businesses use the facility for retreats, conferences, and field trips. (Courtesy of University of Rhode Island archives.)

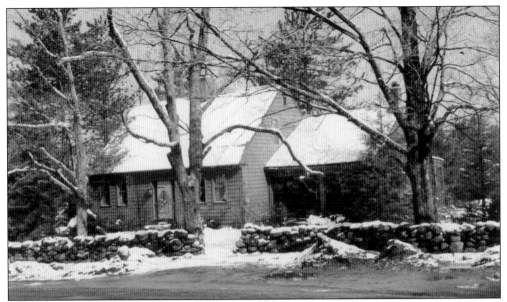

The Stephen Allen house on Sharpe Street was built about 1787. Allen was probably the town's only physician at that time. In the mid-1800s the house was expanded and outbuildings were added. The farmstead is considered a fine example of rural farm life and is listed in the National Register of Historic Places. (Courtesy of West Greenwich Historical Preservation Society.)

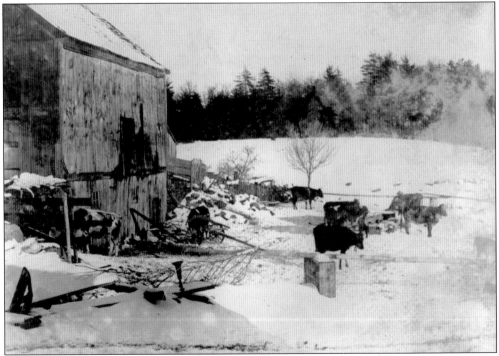

The barn in this undated photograph was located in the rear of the Stephen Allen house. The barn burned down in 1971, but the foundation still exists. Other outbuildings included a school, store, shed, and two-seater privy. Stone walls mark the remains of old pastures. (Courtesy of West Greenwich Historical Preservation Society.)

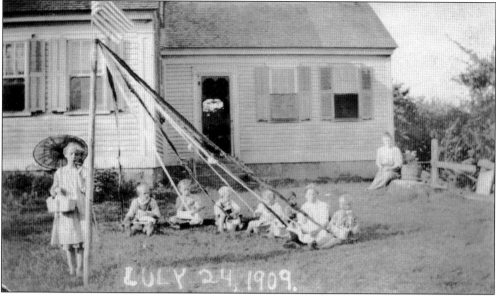

The George Dawley house, located on Congdon Mill Road, was built about 1835. Dawley was the town treasurer and a politician. It later was known as the Bogman farm and then belonged to the Franklin family. In this photograph from July 24, 1909, children are in the farmyard performing a Maypole dance. (Courtesy of Russell M. Franklin.)

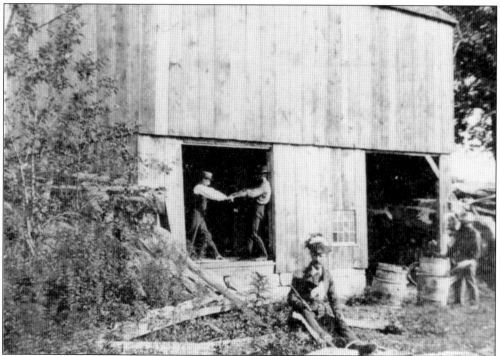

The farmyard in this undated photograph is the site of some interesting activity. It is hard to tell if the men in the doorway are working or dancing. It may be from a Matteson farm because the man with the plumed hat and sword is in the foreground. He can also be seen on pages 17 and 51. (Courtesy of West Greenwich Historical Preservation Society.)

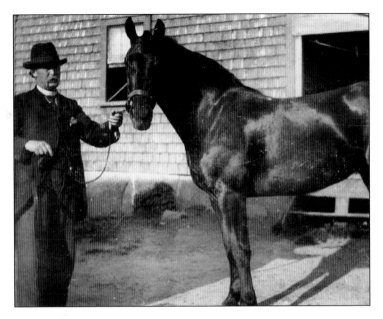

In this undated photograph, Henry Corbin shows off his horse. He is standing in the yard of the Peleg Matteson house, later Millstone Farm. Corbin owned the farm prior to the Mattesons, Louttits, and subsequent families, and he hosted the clambake pictured on page 48. People used many forms of transportation when they needed to leave their homesteads. (Courtesy of West Greenwich Historical Preservation Society.)

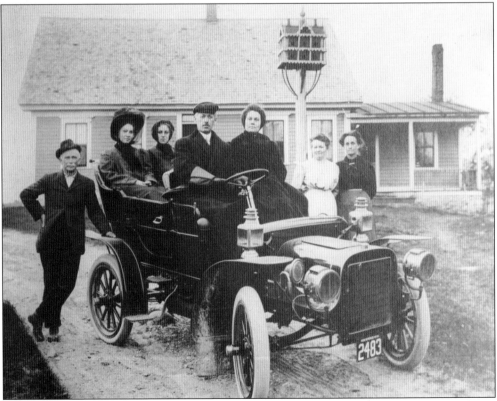

The Whitford-Harrington-Fish house on Weaver Hill Road was built about 1800. In this photograph, taken approximately 1900–1910, unidentified people are posing with a car in the farmyard. The gable-roofed, five-bay house has two one-story additions and is still a private residence and farm. (Courtesy of West Greenwich Historical Preservation Society.)

Four

GETTING AROUND TOWN

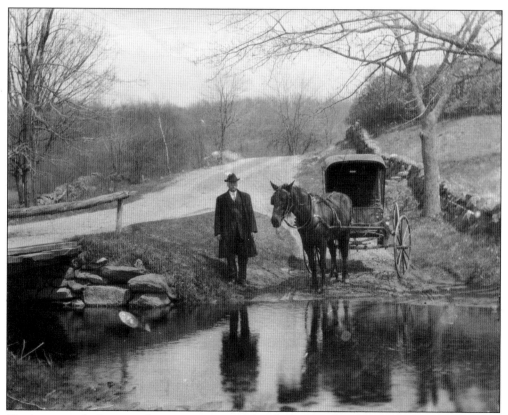

Getting around a large rural town was not easy. Roads were poorly maintained. While there were several decent roads heading north and south, there were few roads going east to west. In this photograph taken around 1910, Searles Capwell has stopped by the brook at the foot of Weaver Hill with his horse Dick. (Courtesy of West Greenwich Historical Preservation Society.)

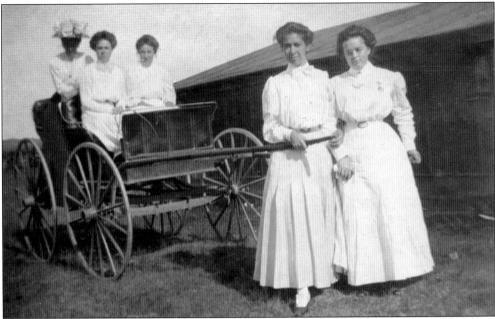

Five unidentified ladies pose with a buggy in this photograph, probably taken in the late 1800s or early 1900s. Judging by their spotless white dresses and their lack of a horse, they do not seem ready to head out. (Courtesy of Frederick Arnold.)

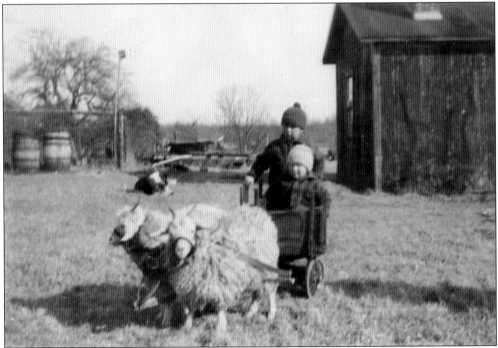

Many creative ways to get around town existed. In this photograph, probably taken in the 1930s, Donald and Bernard Harrington are riding in a cart pulled by their angora goats Nanny and Peggy. The Harrington brothers were well known for the sawmill they operated in town for many years. (Courtesy of Colleen [Harrington] Derjue.)

Pearl Tarbox is taking a ride on her pony Bessie in this undated photograph. She is riding along the banks of Tarbox Pond, on the farm where her family operated the Tarbox and Hopkins sawmill. The road was built to haul the trees and cut lumber from the mill to the drying yard. (Courtesy of Ann Barbour Sundelin.)

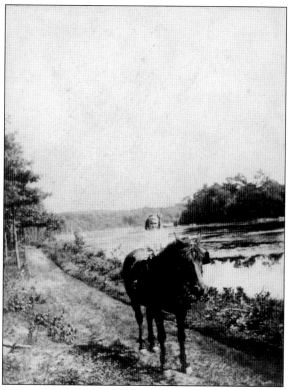

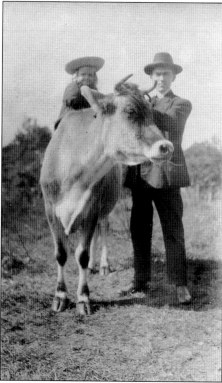

Howard Barbour, Pearl Tarbox's cousin, is also getting around on an animal's back. In this photograph, taken about 1910, Barbour looks slightly uncomfortable on the back of a cow. His father, Henry Barbour, is poised to either catch his son or control the cow, whichever may need his immediate attention. (Courtesy of Ann Barbour Sundelin.)

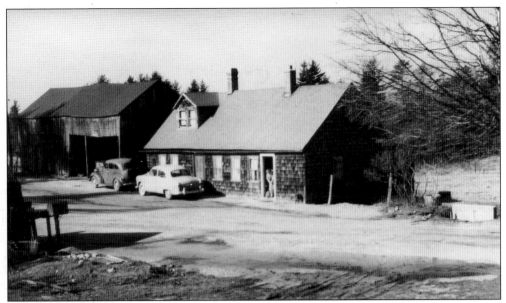

When the New London Turnpike opened to traffic in 1821, its one tollgate in West Greenwich was located at the intersection with Hopkins Hill Road. It was called the Webster Gate. When the turnpike closed, it became a disreputable tavern and eventually closed, becoming a private residence. In this photograph, taken in the early 1950s, Anna Sundelin is sweeping the stoop of her home. (Courtesy of Dorothy Barbour Sundelin.)

The Sundelin family lived in the old turnpike gatehouse from about 1920 until it was condemned by the state as part of the Big River Reservoir project. The family gathered for this 1940s photograph. They are, from left to right, Veikko, Ilmari, Henry, Anna, Sylvia, Olavi, and William. Missing from the photograph is Jorma. The house burned in the 1970s. (Courtesy of John J. Sundelin.)

Nooseneck Hill Road was the center of activity from the late 1800s until the Big River Reservoir project closed most of the businesses and forced many residents to move. This undated photograph shows the road going south. The church on the right has been relocated (see page 83), and the mill at the foot of the hill no longer exists. (Courtesy of West Greenwich Historical Preservation Society.)

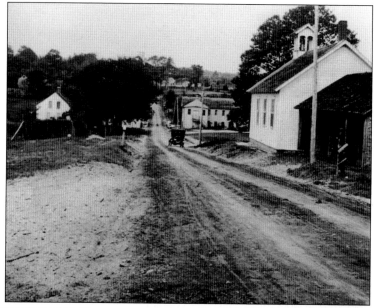

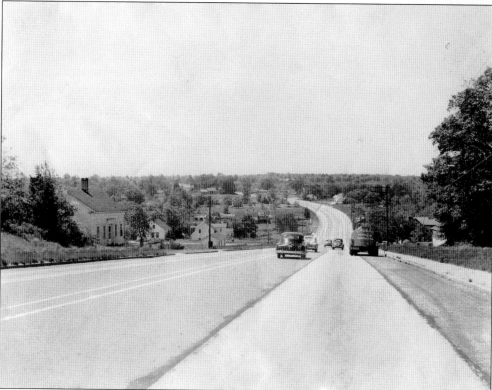

Nooseneck Hill Road was straightened and paved in the 1920s. This coincided with the rise of automobile travel, and the combination dramatically changed the village. It was a popular road that brought new opportunities for business and for socializing. West Greenwich entered a period of growth in its economy, population, and infrastructure. (Courtesy of West Greenwich Historical Preservation Society.)

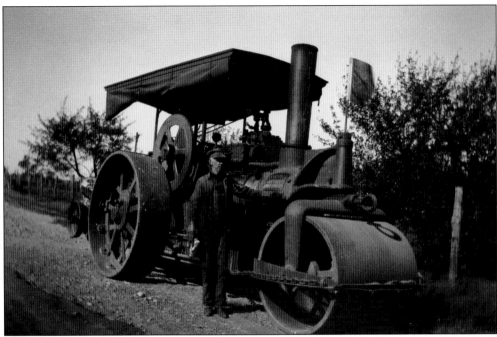

Paving Nooseneck Hill Road was a massive project. This steamroller was used to level the gravel bed after it was laid. The size and weight of the vehicle, combined with the smooth wheels and cylinder (or drum) also flattened the surface. This photograph of the roller and its unidentified operator was taken in 1925. (Courtesy of John J. Sundelin.)

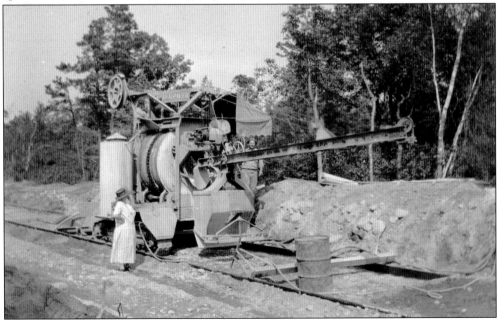

The paving project required substantial amounts of material. In this photograph from 1925, Ella May Tarbox Hopkins is inspecting the machinery at the construction site. The operator behind the machinery is unidentified. The people in the photograph provide a sense of scale when compared to the massive equipment. (Courtesy of John J. Sundelin.)

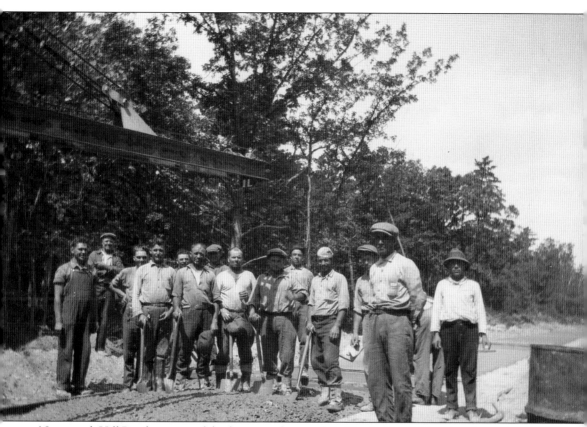

Nooseneck Hill Road was one of the first macadam roads in Rhode Island. Macadam is pavement made of layers of compacted broken stone and a binder. The crew took a break from work to pose for this photograph in 1925. They are standing under a crane that was connected to the machinery used to pour the fresh concrete. Many of the men are spreading the newly poured concrete, wearing boots and wielding shovels. Even with the heavy equipment, much of the work required good old muscle and long hours of hard labor. Howard Barbour is on the left and his brother, Clifton Barbour, is third from the left, partially hidden. The other men are not identified. The Barbour brothers were nephews of Ella May Tarbox Hopkins, who was looking at the machinery in the photograph on page 62. (Courtesy of John J. Sundelin.)

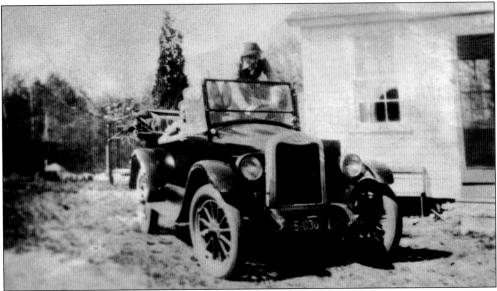

Henry Wright is preparing to speed off in his Chevrolet touring car. This photograph was taken about 1929, in front of his house at the end of Breakhart Road. His unidentified passenger seems ready for the ride, with his feet resting against the windshield. (Courtesy of West Greenwich Historical Preservation Society.)

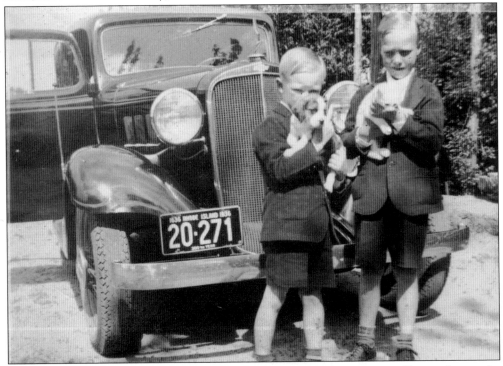

Donald (left) and Bernard Harrington seem more interested in their puppy and kitten than in the shining Chevrolet behind them. This photograph was taken in the spring of 1936. The license plate on the car commemorates the 300th anniversary of the founding of Rhode Island in 1636. (Courtesy of Colleen [Harrington] Derjue.)

Ardis Barbour is riding in her first car, a 1925 Ford touring car. She is letting her brother Clifton Barbour handle the steering while a young gentleman identified as Ralph stands on the running board. The photograph was taken in August 1925 in front of Potter's sawmill in Hopkins Hill. (Courtesy of Ann Barbour Sundelin.)

Clifton Barbour's children continued the family tradition of posing with a car. Harry "Buzz" Barbour (left) is ready to drive off in an early 1930s Ford Model A coupe. His sisters Dorothy Barbour (center) and Ann Barbour are standing in front of the car. This photograph was taken in the 1940s at the family's potato fields in Hopkins Hill, now part of the Big River Management Area. (Courtesy of Ann Barbour Sundelin.)

Joseph "Greasy Joe" Piasczyk ran an automobile salvage business at the corner of Hopkins Hill Road and Division Road. When the state condemned his land for the Big River Reservoir project, he moved his business farther down Division Road, near the intersection with New London Turnpike. He is wearing his trademark bibbers in this undated photograph. (Courtesy of West Greenwich Historical Preservation Society.)

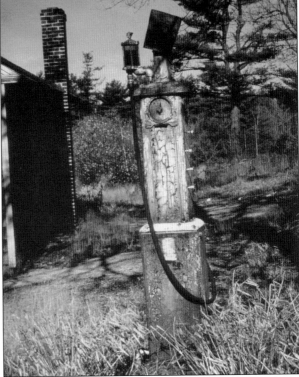

The old gas pump in this undated photograph was near Joseph "Greasy Joe" Piasczyk's junkyard on Division Road. It was used to fill the trucks transporting sand from the dunes (see page 22) to the train station. The pump was lost when the land was taken for the Big River Reservoir project. (Courtesy of West Greenwich Historical Preservation Society.)

Five

SETTING UP SCHOOLS

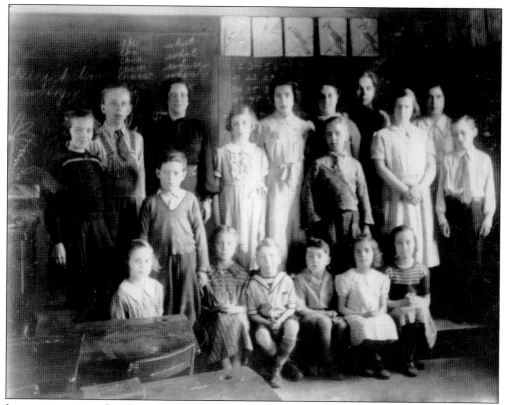

In response to state legislation in 1828, West Greenwich divided the town into 12 school districts. The districts built simple one-room schoolhouses and all grades attended their district school. This undated photograph shows the interior of an early school, including chalkboards and desks with holes for inkwells. Many West Greenwich schools have been photographed; this one is unidentified. (Courtesy of West Greenwich Historical Preservation Society.)

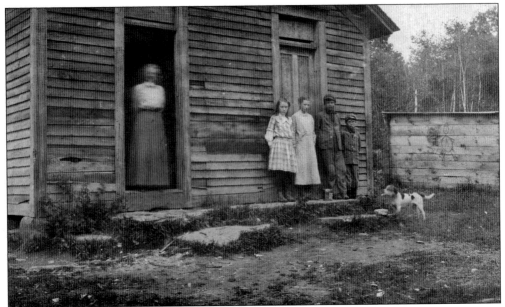

Hitty Corner School was at the corner of Hopkins Hill Road and Bates Trail. This photograph, taken in 1914, shows the school and its woodshed. A stick figure is scrawled on the woodshed facade. The school is now a private residence. The teacher and students are unidentified. (Courtesy of Donald E. Harrington.)

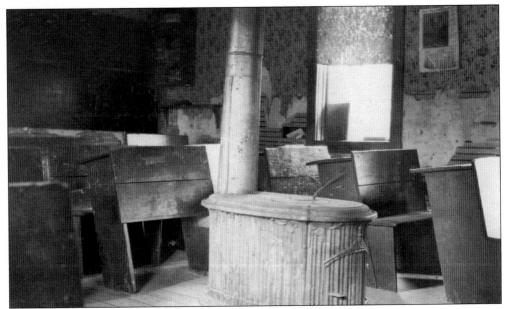

The interior of Hitty School is shown. A central wood stove provided heat, and rows of straight-backed desks provided seating. The calendar on the wall is open to July 1914. In 1929, Hitty Corner School was the site of the first school forestation project in the state, an early indicator of the town's commitment to the environment. (Courtesy of Donald E. Harrington.)

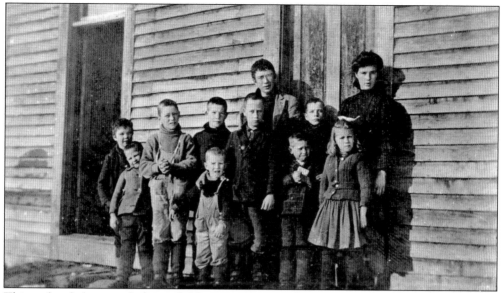

This undated photograph shows children standing outside Hitty Corner School. The tallest girl (back right) is Ethel Kettelle, and the tallest boy (back left) is Chester Kettelle. The small boy (probably first row, second left) is Howard Kettelle. The rest are various members of the Andrews and Harrington families. (Courtesy of Donald E. Harrington.)

By the time of this photograph in 1934, Hitty Corner School was painted white, and one door was replaced with a window. Bernard Harrington is wearing a hat (second row, right). The teacher is Mrs. Lineham, although not the teacher for whom Lineham School was later named (see page 78). The other children are unidentified. (Courtesy of Donald E. Harrington.)

This undated photograph shows the teacher and students of the Escoheag School. In the front row are Francis Money and Ernest Money. The other children are not identified but include Ruth Rathbun Finnity, Annie Rathbun Woosmansee, and Leonard Rathbun. The teacher is Miss Nye. (Courtesy of West Greenwich Historical Preservation Society.)

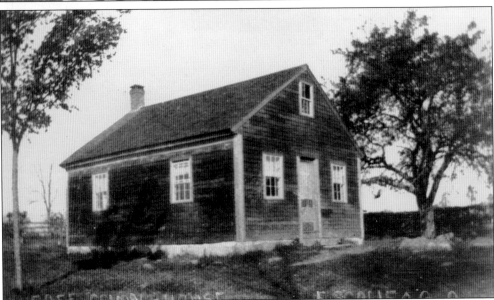

The Escoheag School was one of the few schools with only one front door. It also has a large window on the upper area of the gable end. The school was located on Escoheag Hill Road. The undated photograph is labeled, "Free School House, Escoheag RI." (Courtesy of Russell M. Franklin.)

This school on Plain Meeting House Road was known by several names. Most commonly called "the Plain School," it was also identified as West Greenwich Center School. Some believe it may have been called the Red School House, although another school also had that name. The building, with its distinctive oculus (round window), has been converted into a residence. (Courtesy of the West Greenwich Historical Preservation Society.)

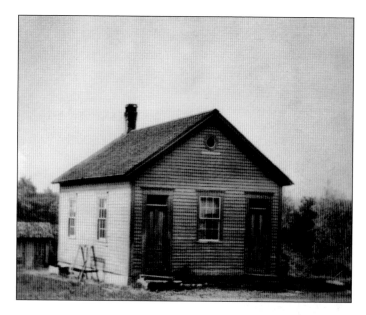

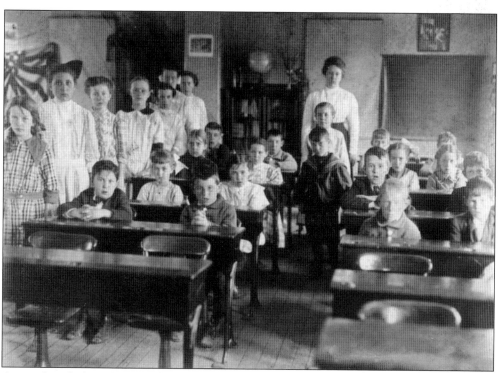

An unidentified teacher and students stopped class to pose for this undated photograph inside a school identified as the Red School House. The space and furnishings show a vast improvement over the interior of Hitty Corner School, with movable chairs and plenty of light. (Courtesy of West Greenwich Historical Preservation Society.)

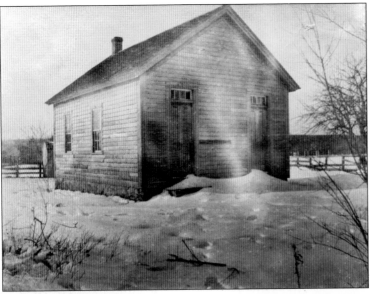

Fry School was located on Fry Pond Road, although on some old maps it was labeled Fry School Road. It is alternately spelled "Frye." Squire G. Wood, who wrote the history of Greene and its vicinity, attended school here in 1875. (Courtesy of West Greenwich Historical Preservation Society.)

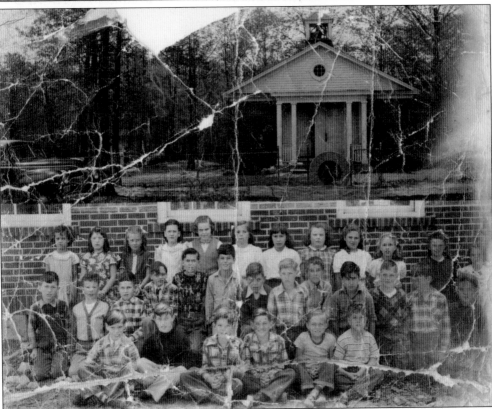

The original Sharp (or Sharpe) Street School burned in 1936. Sophia Louttit built a replacement for the school on land she donated to the town. It was renamed the William E. Louttit Memorial School, in memory of her husband. This photograph, showing Louttit School's third and fourth grades, was taken May 11, 1949. The school was later converted into the town's library. (Courtesy of West Greenwich Historical Preservation Society.)

This photograph of the old Nooseneck School was taken October 5, 1913. The belfry gives a distinctive schoolhouse look to the building. Like the other schools in town, students in grades one through eight attended school together. The two doors, common on most schools in town, were separate entrances, one for boys and the other for girls. (Courtesy of West Greenwich Historical Preservation Society.)

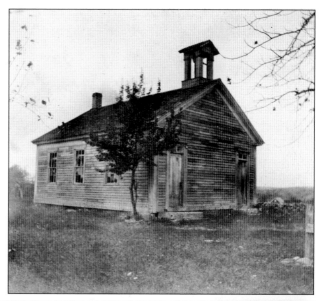

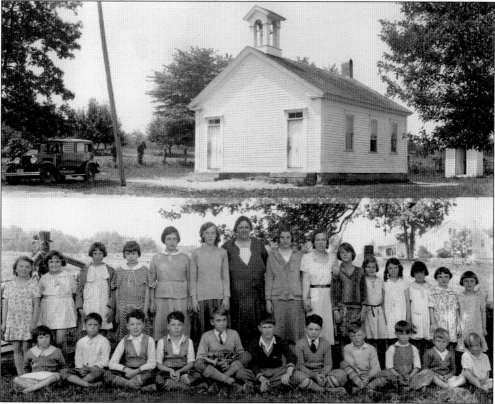

Although it was painted white by the time this photograph was taken around 1931 or 1932, the Nooseneck School retained its schoolhouse charm. The teacher (back row, center) was Phoebe Moore. Many of the students are identified on the back of the photograph. Family names include Hoxsie, Morton, Fish, Sprague, and Gileau. The school has been converted to a residence. (Courtesy of West Greenwich Historical Preservation Society.)

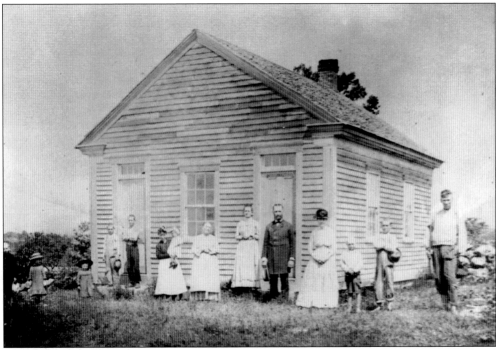

The Lewis School was a classically designed, two-door, one-room schoolhouse. This undated photograph shows people of all ages gathered in front of the school. The school is believed to have been in the Escoheag area, but few records exist. It is not listed in the original 12 school districts in West Greenwich. (Courtesy of West Greenwich Historical Preservation Society.)

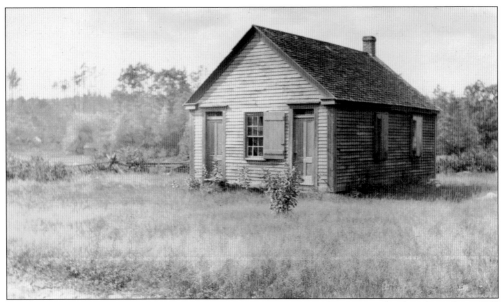

Button's or Burton's Corner School was located on the corner of Division Road and Hopkins Hill Road. There is little information about this school, and few photographs could be found. This undated photograph shows its two doors and large center window. The shutter on the window is unusual. (Courtesy of John J. Sundelin.)

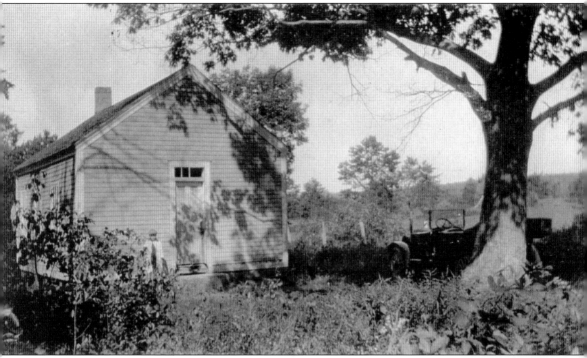

This photograph of the Parker School was taken in September 1916. It is one of the few schools with only one door. The outhouse is not visible in this photograph. Parker School was typical of the one-room schools in West Greenwich. Heat was provided by oil-fueled pot-burner stoves. The school had neither running water nor indoor toilet facilities. Drinking water had to be hauled to the school. Students of all grades were taught by one teacher, who also taught all subjects. The one-room schools were in operation until 1951, when the new consolidated elementary school opened. Parker School was located on property near the conference center facilities on what is now the W. Alton Jones campus of the University of Rhode Island. (Courtesy of West Greenwich Historical Preservation Society.)

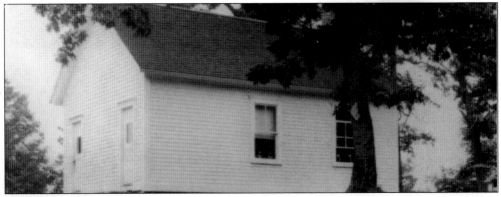

Kitt's Corner School was located on Kitt's Corner Road in the eastern end of West Greenwich. This photograph was taken about 1930. It shows a crisply painted white school with the typical two doors. The school is no longer standing. It was located very close to where Interstate 95 crosses through town. (Courtesy of Kevin A. Breene.)

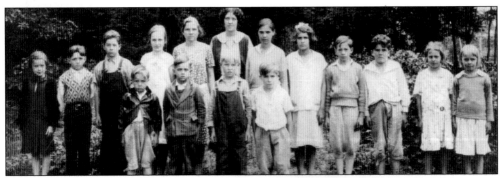

This photograph, also from about 1930, shows children attending Kitt's Corner School. The children are identified on the back of the photograph; family names included Albro, Pysz, Fish, and Merikoski. The teacher was Hope Andrews (back row, center). Children brought their sleds to school in the winter to slide down a big hill behind the school. (Courtesy of Kevin A. Breene.)

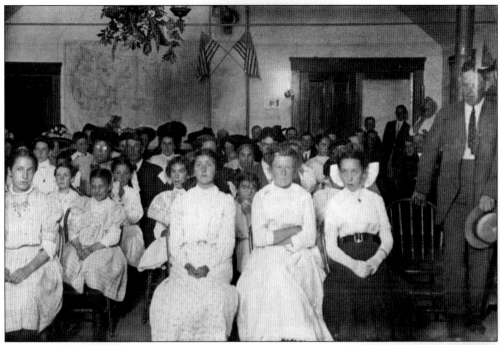

There are conflicting descriptions of this undated photograph. While some believe it is a graduation ceremony in the old town hall (see page 98, bottom), others say the interior does not match that description. It may be a meeting in the meeting room of the Nooseneck Valley Mill (see page 20). (Courtesy of West Greenwich Historical Preservation Society.)

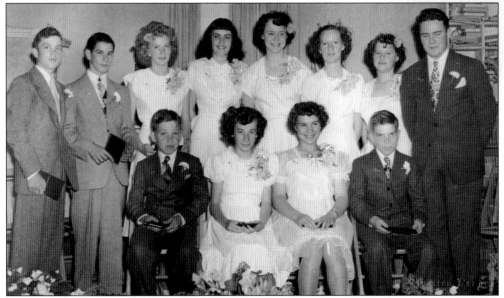

This is the graduating class of Nooseneck Hill School in 1948, photographed in the old town hall (shown on the bottom of page 98). From left to right are (first row) Joe Swiencki, Shirley Kozela, Bev Andrews, and Russell Green; (second row) Jim Lamoureux, Frank Buffi, Dotty Melbourne, Joan Riley, Louise Thurston, Irene Ellis, Dawn Martin, and Teddy Briggs. (Courtesy of West Greenwich Historical Preservation Society.)

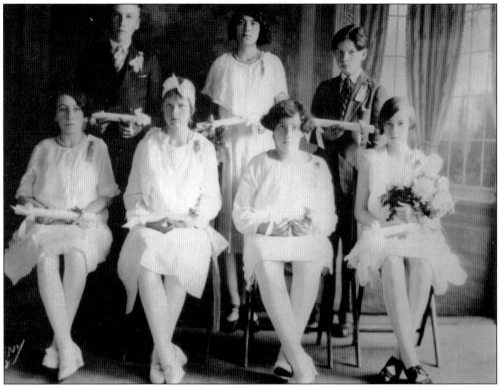

The West Greenwich graduating class of 1928 included students from Kitt's Corner, Hitty Corner, Nooseneck, and Sharp Street Schools. This was the first class that the town paid tuition for them to attend a neighboring high school. From left to right are (first row) Ada Andrews, Elsie Olsson, Alice Fish, and Carolyn Albro; (second row) Leon Andrews Jr., Jessie Dupre, and Merrill Albro. (Courtesy of West Greenwich Historical Preservation Society.)

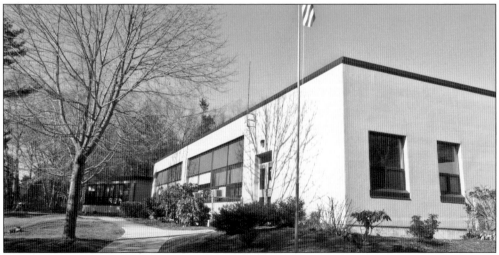

West Greenwich Consolidated School was built in 1950 on the site of the old Civilian Conservation Corps camp at Nooseneck. Students from the remaining one-room schoolhouses were able to attend together, at one school. An addition was constructed in 1957 and the school was renamed the Mildred E. Lineham School in 1967 to honor an outstanding educator. (Photograph by Brian R. Swann.)

Six

GROUPS, GATHERING PLACES, AND FUN

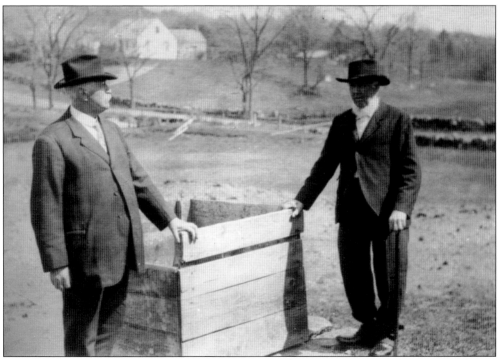

Brothers Searles (left) and Thurston Capwell meet at the well to discuss important matters. The site looks toward Weaver Hill from the Searles Capwell farm. The people in West Greenwich were largely isolated from the more populated areas in the state. They were resourceful and found many places to meet, many ways to organize themselves, and many ways to have fun. (Courtesy of West Greenwich Historical Preservation Society.)

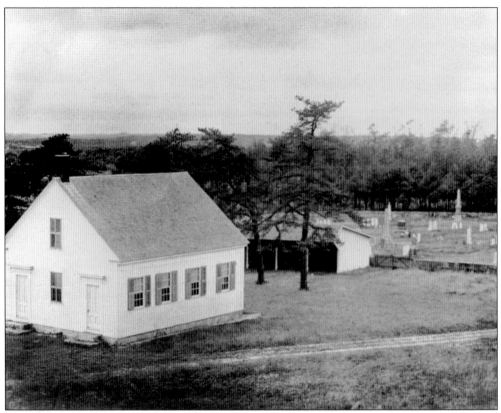

The West Greenwich Centre Baptist Church was built about 1825 and remodeled in 1856. It is commonly referred to as the Plain Meeting House because it is located on a flat so-called plain. A long carriage shed, seen in this photograph from May 23, 1920, was destroyed by the hurricane in 1938. It is now owned and managed by the West Greenwich Land Trust. (Courtesy of West Greenwich Historical Preservation Society.)

The Free Will Baptist Church, also called the Sharpe Street Baptist Church, was built approximately 1860. The land to build the church was given by Nathan Matteson. The land and building were sold to a private person in 1946. It is now a residence. This undated photograph shows the wife of Rev. Earl Tomlin. (Courtesy of West Greenwich Historical Preservation Society.)

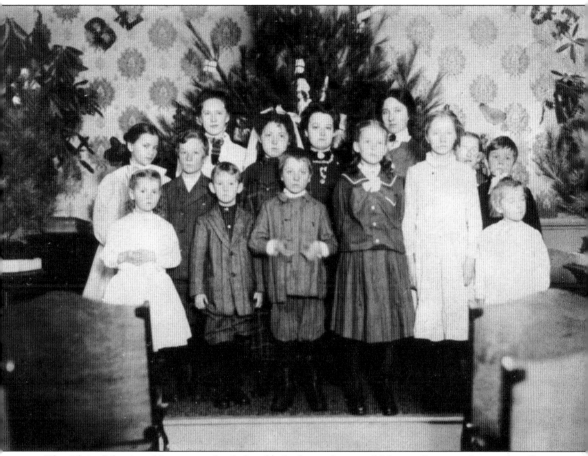

The Plain Meeting House was built by the Independent and Union Society, for use by all Christian congregations. It was formed when members of the society requested a branch of the Maploot Church be opened at a location more convenient for the people in the western part of West Greenwich. Its charter was granted on January 20, 1822. In 1856, the church merged with West Greenwich Baptist Church. It is believed that Rev. William C. Manchester founded the church. Its simple clapboard structure, with no steeple or belfry, is a valuable example of modest church construction. It was donated to the West Greenwich Land Trust in 2005. This nonprofit organization maintains the property and ensures it continues to be a gathering place. This undated photograph shows children at a Christmas church service at Plain Meeting House. (Courtesy of West Greenwich Historical Preservation Society.)

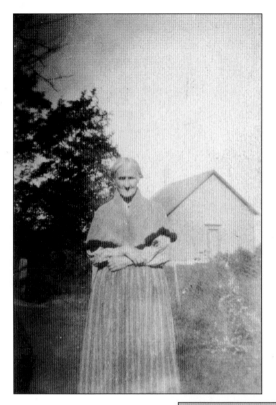

The Tarbox Church was built with donations from the Tarbox family. It was located near Carr's Pond, where the family had lived for many generations, operating a quarry and logging business. This photograph of 81-year-old Sally Cleveland Tarbox, taken in 1909, shows the Tarbox Church in the background. (Courtesy of John J. Sundelin.)

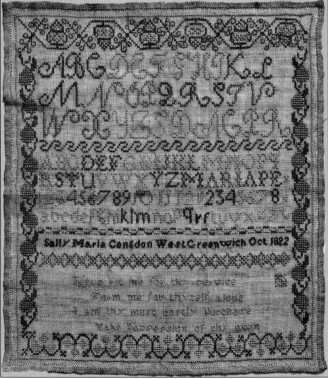

This sampler was made in 1822 by Sally Maria Congdon, Sally Cleveland Tarbox's aunt and namesake. Congdon lived and was buried in the area along Congdon Mill Road. This needlework piece is an example of the Rhode Island schoolgirl sampler style. It has remained in the family. (Courtesy of Kathleen A. Swann.)

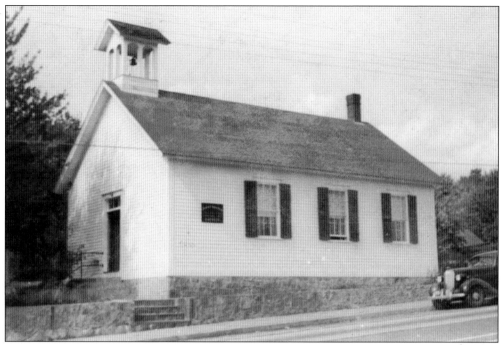

The Nooseneck Baptist Church was organized in 1785, and the building was constructed about 1891. It was originally on Nooseneck Hill Road, as shown in this undated photograph. Its first location can also be seen on page 61, in the photograph of Nooseneck Hill Road before it was paved. (Courtesy of West Greenwich Historical Preservation Society.)

The Nooseneck Baptist Church was moved to Victory Highway in 1971, when its original location was condemned by the state for the Big River Reservoir project. It is now located near the municipal center of town. It still has the small belfry and continues to function as a church. (Courtesy of West Greenwich Historical Preservation Society.)

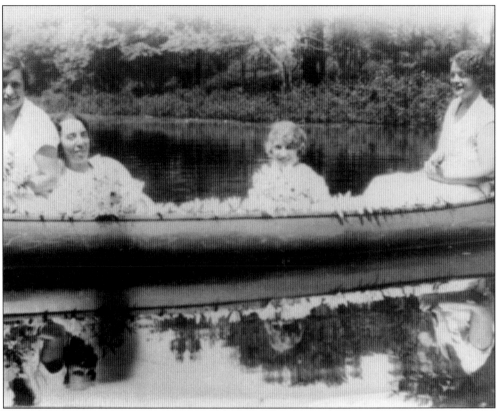

Lake Mishnock, in the eastern end of West Greenwich, grew in popularity as a summer colony in the early 20th century. This undated photograph was probably taken at about that time. Susie Northup (far left) is gathering water lilies with unidentified friends. They are obviously enjoying a canoe ride on the still, clear lake. (Courtesy of West Greenwich Historical Preservation Society.)

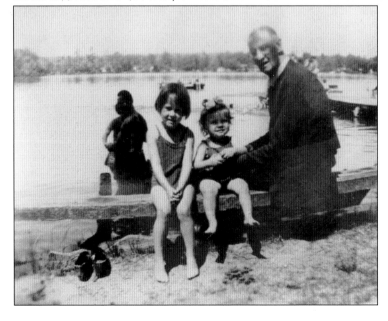

Dorsey J. Stillman spent a day at Lake Mishnock with his granddaughters, in this photograph from about 1944. Roberta Smith Baker and her sister Carolyn learned to swim at Lake Mishnock. Many local families came to swim at the lake. Others made day trips or rented summer cottages along the lake. (Courtesy of West Greenwich Historical Preservation Society.)

Mishnock Grove was a hub of summer activity between the 1940s and 1960s, offering swimming, roller-skating, and a carousel. Clambakes were popular fundraisers, and the one in this undated photograph raised funds for a local fire company. The bake master was Frank Sprague, known as Little Giant. Sprague can also be seen climbing a fire tower on page 101. (Courtesy of West Greenwich Historical Preservation Society.)

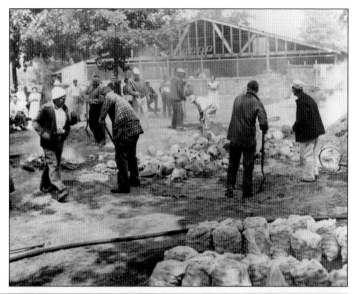

These vacation cottages at Lake Mishnock became popular with the increased automobile travel that followed the paving of Nooseneck Hill Road in the late 1920s. They created a bustling summer colony in an otherwise quiet, rural town, and Lake Mishnock became a popular recreation area. The cottages gradually became year-round homes, and the lake lost its allure as a vacation spot. (Courtesy of West Greenwich Historical Preservation Society.)

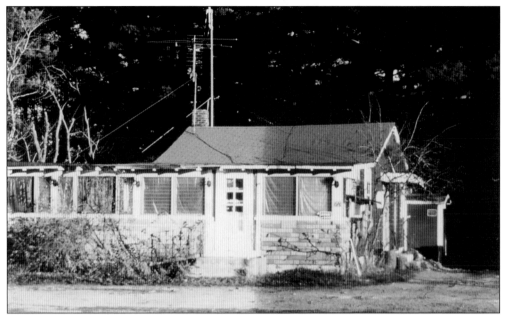

The Wayside Inn, later the Big River Restaurant, opened in 1928 on Nooseneck Hill Road. Susie Matteson Harrington started the restaurant; later, her daughter, Cora Lamoureux, helped. Both women were very involved in community service. Lamoureux served as town clerk for many years. The building was condemned as part of the Big River Reservoir project and has been demolished. (Courtesy of West Greenwich Historical Preservation Society.)

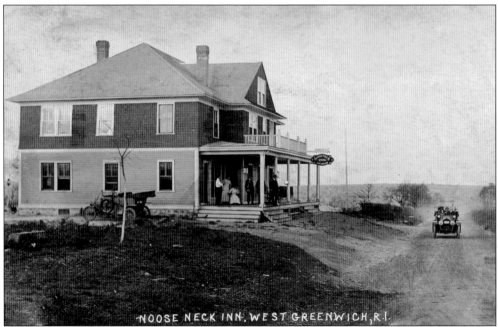

This postcard was sent to Elsie Franklin by her mother in 1914. It shows the Nooseneck Inn before Nooseneck Hill Road was paved. The view from the top of Nooseneck Hill is dramatic because the logging business had removed many trees. The wide porch was obviously a popular gathering spot. (Courtesy of Russell M. Franklin.)

The Nooseneck Inn looked much the same in this photograph from September 1, 1920. The annual West Greenwich Old Home Days event was held here. More than 1,000 people attended the clambakes and ceremonies. The town's war memorial is in the foreground (see page 107). Mike Duff ran the inn from 1923 to 1959, starting and organizing many of these events. (Courtesy of West Greenwich Historical Preservation Society.)

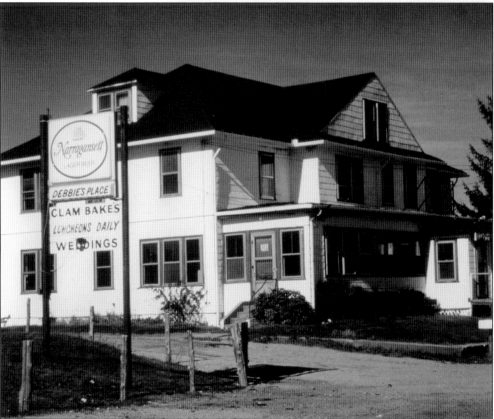

The Nooseneck Inn was known as Debbie's Place in this 1975 photograph. The porch was enclosed, and growing trees obstructed some of the panoramic view. Nooseneck was no longer a bustling village. Most of the businesses and homes around the inn were condemned by the state for the Big River Reservoir project. Several subsequent owners have kept the restaurant in business. (Courtesy of West Greenwich Historical Preservation Society.)

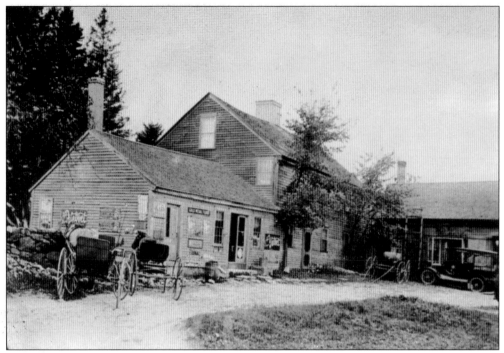

Carr's store was on the corner of Nooseneck Hill Road and Robin Hollow Road, on a corner across from the Nooseneck Inn. This photograph from May 25, 1919, shows the rambling structure that housed Willis Carr's store and rooms used for meetings and gatherings. The town council met on the second floor, and for many years, this was the municipal center of town. (Courtesy of West Greenwich Historical Preservation Society.)

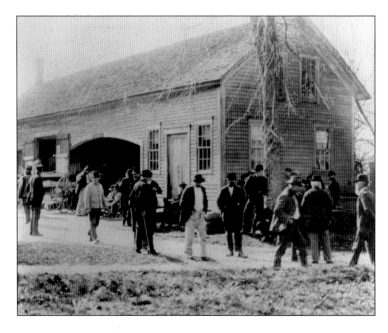

This photograph of Carr's store shows an ell on the building that housed a carriage shed and other rooms. This is where residents came to vote. It is possible that the photograph was taken on election day, given the crowd of people in the yard. The section shown in the top photograph burned and this ell was demolished in the late 1980s. (Courtesy of West Greenwich Historical Preservation Society.)

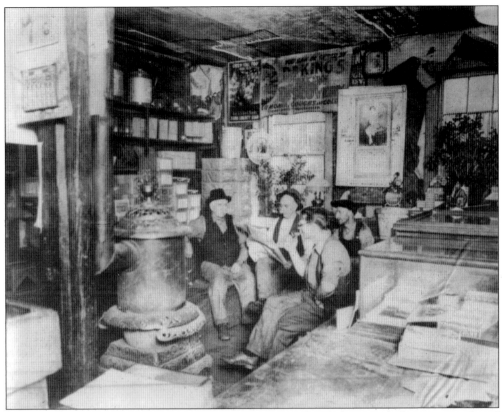

Fish's store was in the old Nooseneck Valley Mill. This undated photograph shows men gathered around the potbellied stove, fitting a description of the store published in 1927. Fish had been a state representative, and politics would certainly be a topic among the men who gathered there. Pictured are, from left to right, Stephen Kettle, owner James Fish, Joseph Westgate, and Walter Gardiner. (Courtesy of West Greenwich Historical Preservation Society.)

This undated photograph shows Edwin "Shug" Hoxsie Sr. in his store and gas station on Nooseneck Hill Road. His store was known for its excellent johnnycake meal. Hoxsie was a forester for the state and was the head advisor to the Nooseneck Hill CCC camp in the 1930s. He also served as a volunteer firefighter and was active in politics. (Courtesy of West Greenwich Historical Preservation Society.)

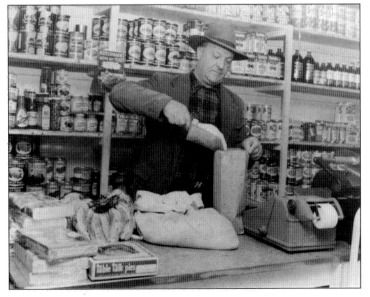

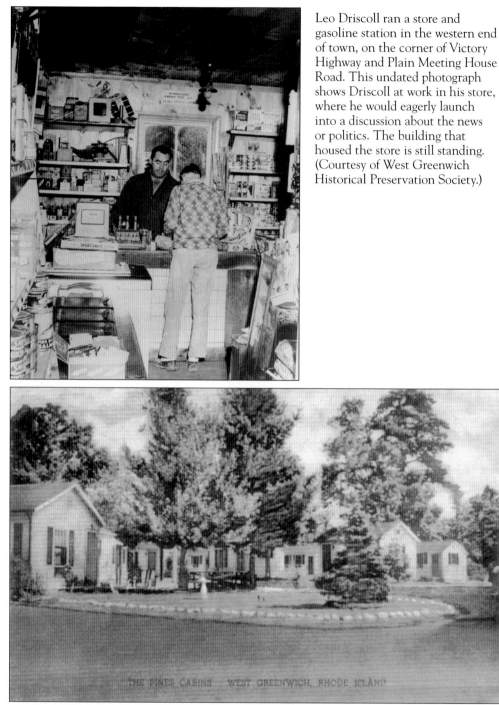

Leo Driscoll ran a store and gasoline station in the western end of town, on the corner of Victory Highway and Plain Meeting House Road. This undated photograph shows Driscoll at work in his store, where he would eagerly launch into a discussion about the news or politics. The building that housed the store is still standing. (Courtesy of West Greenwich Historical Preservation Society.)

The Pines Motel, shown in this postcard probably from the late 1940s, was a collection of cabins along Nooseneck Hill Road. They became popular after the road was paved and became a well-traveled automobile route. The cabins were purchased and operated by Herman and Elly Rusack in 1947. They were the last roadside cabins to close in West Greenwich and are now demolished. (Courtesy of West Greenwich Historical Preservation Society.)

Thurston Albro opened a restaurant called Princess Pines in this building on Nooseneck Hill Road. He planted seedling pines around the site. They are still growing in this photograph from September 16, 1978. He later used the building as a store, informally known by Albro's nickname, "the Sheriff's Variety." When Albro died in 1960, his son Ralph took over the store. (Courtesy of Gloria Albro Silverman.)

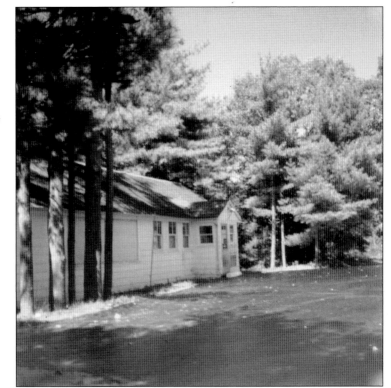

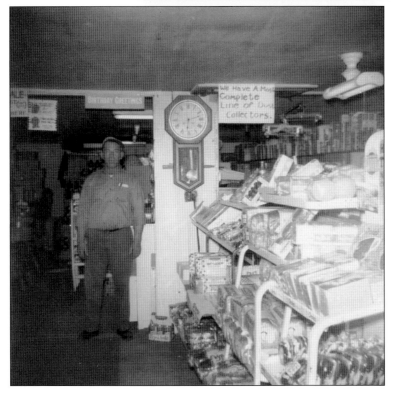

Ralph Albro's store carried grocery items and decorative objects. In this photograph from June 1960, Albro is standing under one of his favorite signs, which read, "We have a most complete line of dust collectors." The store is closed, but the building is still standing. (Courtesy of Gloria Albro Silverman.)

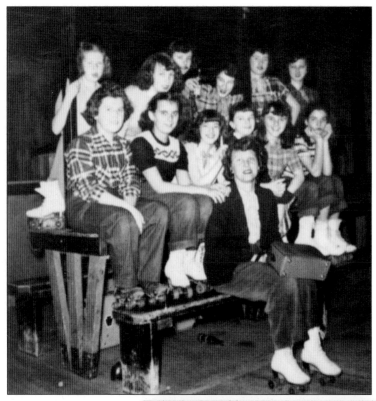

The West Greenwich Girl Scouts are enjoying a roller-skating trip at Lake Mishnock in this photograph from February 6, 1952. The leader, Ruth Yeager, is in front. The girls are, in no particular order, Lois Searle, Denise Hobday, Emma Asselin, Carol Franklin, June Andrews, Doris Andrews, Janice Renehan, Gertrude Patterson, Dotty Asselin, Regina Wilkins, Susan McConnell, and Kathy Meehan. (Courtesy of West Greenwich Historical Preservation Society.)

This photograph is from the 1960 opening ceremonies of Boy Scout Troop 35. The troop was organized as Mishnock, but is now the West Greenwich troop. The scoutmaster is Stan Demers. Billy Potter is on the far right, and Owen Dunbar is second from the right. The other boys are not identified. The troop is still very active in the community. (Courtesy of Paul Sweet.)

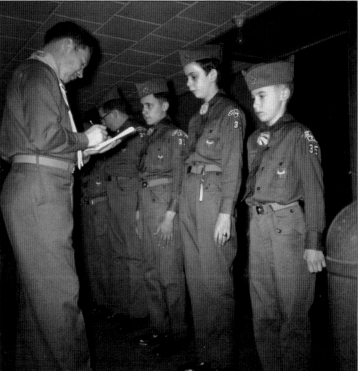

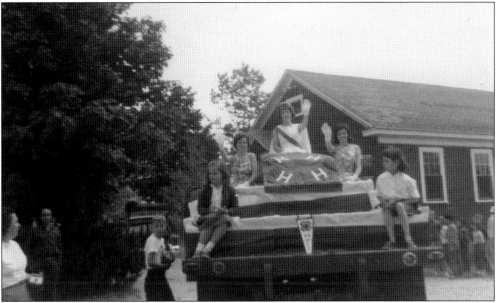

The annual Memorial Day parade marched by the old town hall each year. In this photograph from 1964 or 1965, Beverly Franklin Grundy is waving from the center of the 4-H float. Arlene Franklin (left) and Diane Morton Andrews (right) are with her. The others are unidentified. (Courtesy of Russell M. Franklin.)

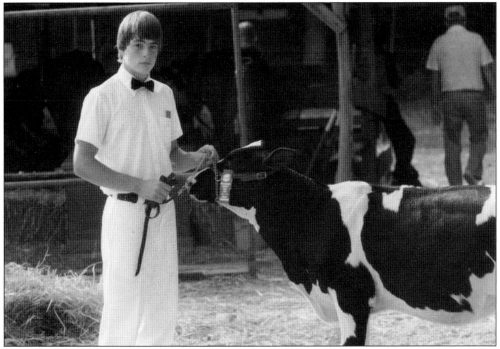

Raising livestock and participating in the local fairs are big parts of life in a rural town. The West Greenwich 4-H programs are very active. Buster Andrews and his cow Annabelle won a blue ribbon in the dairy competition at the 1980 4-H Fair at Washington County Fairgrounds. (Courtesy of the Andrews family.)

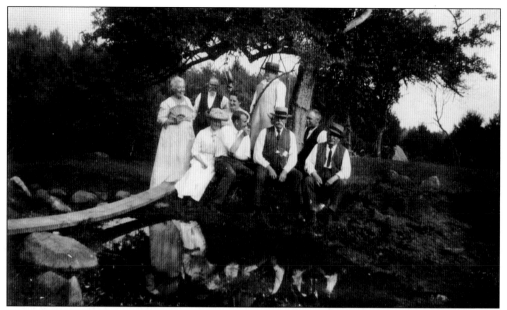

People gathered at the Charlie Place, near what is now Exit 6 from Interstate 95, on Nooseneck Hill Road. This photograph from the early 1900s includes, from left to right, (first row) Mr. and Mrs. Putnam, Searles Capwell, Alanson Albro, and Everett Andrews; (second row) Eva Albro, Mr. and Mrs. Watson, and an unidentified person. (Courtesy of Kevin A. Breene.)

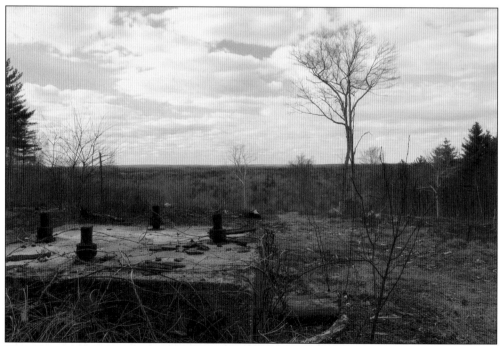

West Greenwich had a popular skiing area in Escoheag. Pine Top operated from the mid-1960s to the early 1980s. It had two T-bars and two rope tows. In the 1970s, Pine Top had 20 ski instructors. The land is now owned by the state. This recent photograph shows what remains of the T-bars and tows at the top of the hill. (Photograph by Brian R. Swann.)

Seven

A GOVERNMENT FORMS

Samuel Kettelle, West Greenwich tax collector and town treasurer, is signing off the town debt in this 1926 photograph. He is sitting at his desk at the Old Home place, the family homestead in the Hopkins Hill area. West Greenwich residents continue to monitor the town's finances closely and are proud of its fiscal stability. (Courtesy of Colleen [Harrington] Derjue.)

John Bates was the postmaster at West Greenwich Center. He and his wife, Emma, are shown at their home on Plain Meeting House Road on July 11, 1926. Bates held the position for 34 years, taking it over from his father. The post office was discontinued and later destroyed by fire in 1930. (Courtesy of West Greenwich Historical Preservation Society.)

The Rathbun homestead, shown in this undated photograph, was located at the intersection of Escoheag Road and Falls River Road. It operated as a post office at one time. West Greenwich has no local post office now, but it did finally get its own zip code in the late 1980s. (Courtesy of West Greenwich Historical Preservation Society.)

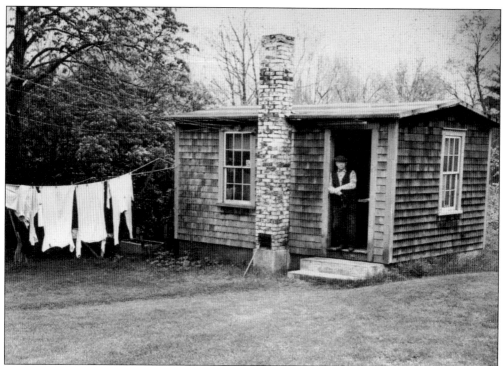

As town clerk, Erving Matteson believed there should be an office to conduct business and store town records. The town could not afford one, so Matteson built this town clerk's office behind his own home, the Kitt's Corner tavern. He is standing in the doorway in this undated photograph. (Courtesy of West Greenwich Historical Preservation Society.)

Erving Matteson (left) is meeting with Thomas Lineham in this 1954 photograph. They are working at a table in the town clerk's office behind Matteson's house. Matteson was also a telegraph operator. The equipment can be seen in his office, and the wires are evident in the prior photograph. (Courtesy of West Greenwich Historical Preservation Society.)

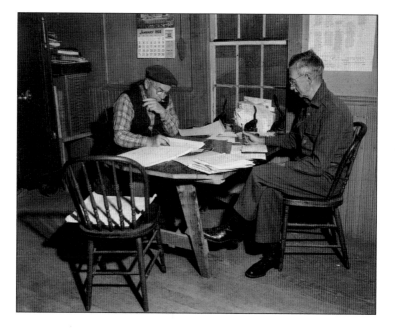

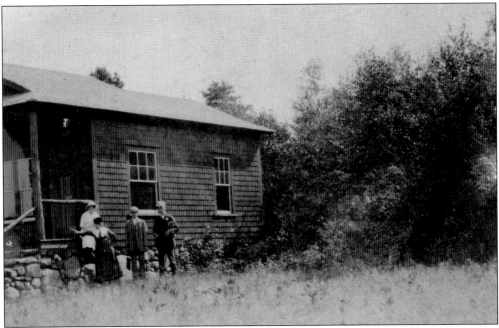

This photograph, from the late 1890s or early 1900s, is identified as the West Greenwich Town Hall. Before the town hall was built in 1937, the town council met in various locations. Town officials and historians agree it is possible this building may have been an undocumented meeting place for conducting town business. (Courtesy of the Pysz and Hoxsie families.)

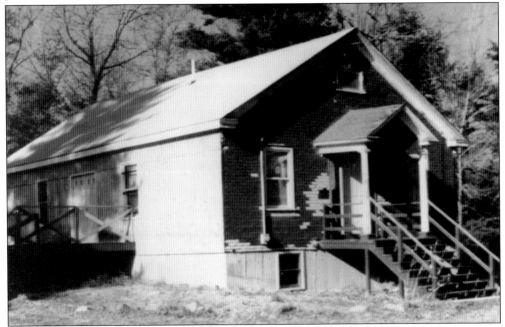

The first West Greenwich town hall was built in 1937. It was a small, one-room building that also served as a school. When the land was condemned by the state for the Big River Reservoir project, the town hall was moved from its location on Old Town Hall Road to a spot on the Lineham Elementary School property. (Courtesy of West Greenwich Historical Preservation Society.)

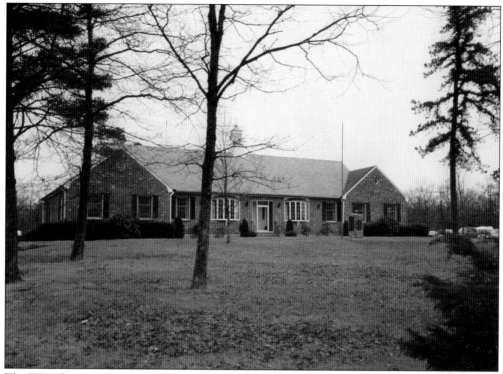

The West Greenwich town hall, built in 1970, is the center of municipal activity in the town. It houses town administrative offices, the police department, and meeting space. The town's granite monument dedicated to war veterans is on the front lawn. Louttit Library is next door, and the town's building officials are housed in a nearby separate building. (Courtesy of West Greenwich Historical Preservation Society.)

The Louttit Library was originally a school built by the Louttit family to replace the burned Sharpe Street School (see page 72). The school closed in 1951 and was converted to the town library. This 1978 photograph shows the library being moved to its present location next to town hall. It has been added on to several times. (Courtesy of West Greenwich Historical Preservation Society.)

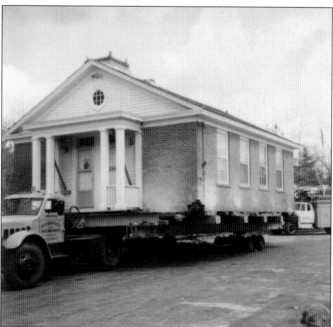

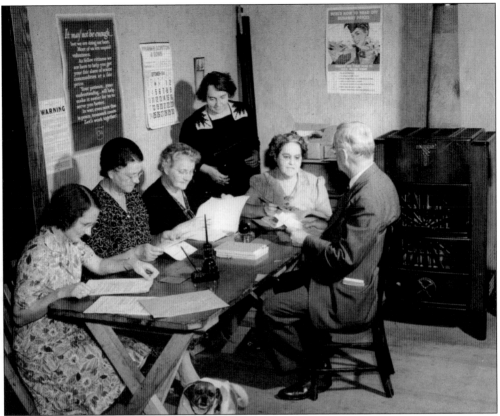

The War Rationing Board met in the old town hall in this undated photograph. The board was responsible for controlling distribution of materials that were in short supply during World War II, including gasoline, certain rubber, and food products. The members pictured are, from left to right, Lillian Martin, unidentified, Ethel Albro, Cora Lamoureux, Emily Albro, and Brad Kenyon. (Courtesy of the Town of West Greenwich.)

Harry Andrews worked to ensure the police force in West Greenwich was professional and trained well. In his part-time position as chief of police, he raised money for uniforms and got a used police cruiser. Andrews is shown in an undated photograph. The West Greenwich Police Department now has a permanent headquarters and continues to boast a professional, well-equipped force. (Courtesy of the Town of West Greenwich.)

Forest fires were a constant threat to a community based on the lumber industry. This fire tower was erected by men of the CCC in 1933, on Rattlesnake Ledge in the Wickaboxet Management Area. The 1936 photograph shows Frank Sprague climbing the tower and his Chrysler parked below. Sprague was also known as the bake master for local clambakes (see page 85). (Courtesy of Burton Andrews III.)

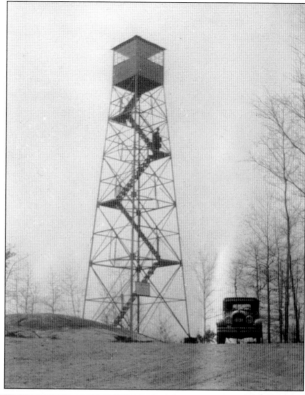

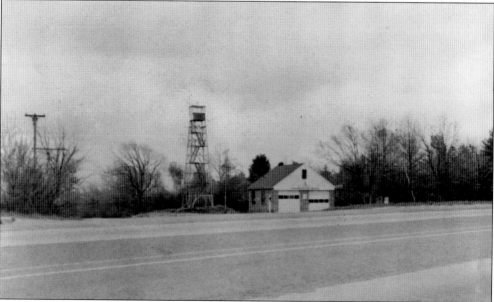

Volunteers dismantled the Wickaboxet fire tower and re-erected it at the West Greenwich Volunteer Fire Company No. 1 station. The fire company was created in 1945. This photograph from the late 1940s shows the original two-bay station. Today, three fire companies in West Greenwich work together to monitor and fight fires and to provide emergency medical treatment and rescue services. (Courtesy of West Greenwich Historical Preservation Society.)

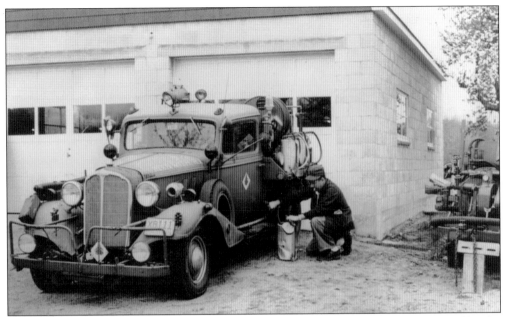

The Hianloland Fire Company, the first fire company in West Greenwich, was started by the Louttit family to serve Hianloland Farms and the town. It incorporated in 1940 and built a station in 1953. Robert Bonner, engineer of the Hianloland Farms Fire Engine Company, also had his own one-man unit, shown in this undated photograph. (Courtesy of West Greenwich Historical Preservation Society.)

The Lake Mishnock Volunteer Fire Company serves the eastern end of West Greenwich. This undated photograph shows the old Mishnock fire station. The company, founded in 1951, is now a full-service fire station and offers a search-and-rescue service. Volunteer firefighters are essential in combatting fires, which are dangerous and can burn so hot they destroy homes, forests, and the soil. (Courtesy of West Greenwich Historical Preservation Society.)

Eight

FACES, FAME, AND FOLKLORE

West Greenwich is a community with many different people, each with unique qualities, personalities, skills, and ambitions. Many are descended from the founding families. Family relationships and social networks are complex. This photograph shows Hattie Melissa Hopkins Harrington, whose son Earl Harrington married Samuel Kettelle's daughter. Kettelle is on page 95, signing off the town debt. (Courtesy Colleen [Harrington] Derjue.)

West Greenwich residents bravely defend the country. Many fought in the Civil War, including these soldiers of Battery B, 1st Rhode Island Light Artillery. This undated photograph shows the troops mounted and the horses hitched, ready to march. Battery D also included West Greenwich residents. (Courtesy of West Greenwich Historical Preservation Society.)

These Civil War veterans were attending a memorial service at Old Home Days, an annual event at the Nooseneck Inn with an old-fashioned farmers' dinner, speeches, and parades. The event started in 1919 to dedicate the war memorial and continued into the 1930s. Hundreds of people attended. The man on the left may be Stephen Kettle; the others are not identified. (Courtesy of West Greenwich Historical Preservation Society.)

John T. Godfrey was an American fighter pilot and captain in World War II. He achieved 18 air-to-air kills and was held as a prisoner of war. After the war, he married Joan Beattie and moved to West Greenwich where he operated lace mills with his father-in-law, James Beattie. Godfrey also served as state senator from West Greenwich. (Courtesy of the Godfrey family.)

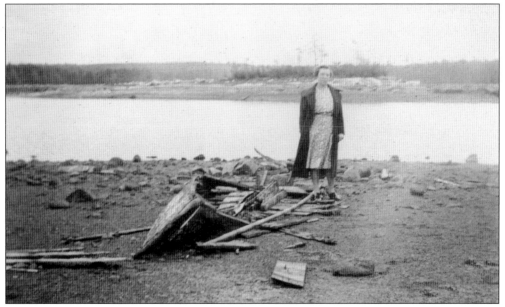

World War II affected daily life in West Greenwich. In this photograph, Mildred Kettelle Harrington is standing in Carr's Pond. The pond was drained to provide water for Quonset, a Naval air station and Navy base east of West Greenwich. The Navy also condemned and occupied homes and land in the Hopkins Hill area for training maneuvers. (Courtesy of Colleen [Harrington] Derjue.)

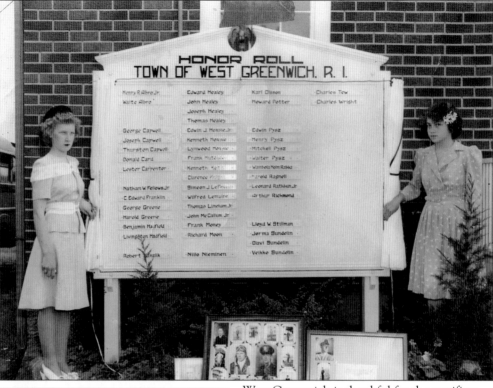

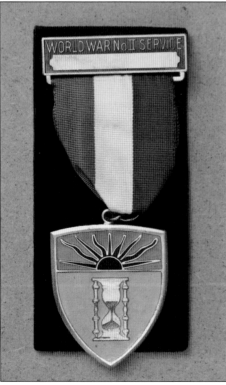

West Greenwich is thankful for the sacrifices of its war veterans and is proud to honor them. This photograph was taken on May 30, 1943, at the old town hall, as the World War II Honor Roll was unveiled. The young women are Marilyn Hoxsie (left) and Cecelia Pysz, whose brothers were killed in action. (Courtesy of Town of West Greenwich.)

The town held a special ceremony on May 30, 1943, to welcome home the World War II servicemen and women. Each veteran was awarded a medal in honor of his or her service. This medal was awarded to Edwin E. Pysz, who later became a state police officer. (Courtesy of the Pysz and Hoxsie families.)

Mary Hale Hicks	Howard Potter
Robert M. Holmes	Lawrence Potter
James A. Horne	Geoffroy Provencher
Benjamin Hoxsie	Niel A. Pynnonen
Edwin J. Hoxsie, Jr.	Edwin Pysz
Lynwood F. Hoxsie	Henry Pysz
Frank G. Hutcheon	Mitchell Pysz
Agenor R. Joyal	Harold Ragnell
Hilton Kettle	Eulan Rajotte
Kenneth Kettle	Gilbert Rathbun
Llewellyn Kettelle	Leonard I. Rathbun, Jr.
Clarence Knight	Arthur Richmond
Verton Knight	Manuel Rosmaninho
Simeon LeFevre	Gerard Roy
Wilfred Lemaire	Pentti A. Stock
Thomas Lineham, Jr.	Llyod Stillman
William Mitchell	Ilmari Sundelin
Frank B. Money	Jorma Sundelin
David Moore	Olavi Sundelin
Harold Morton	Veikko Sundelin
Elmer McCallum	Charles Tew
John P. McCallum, Jr.	Edward Tinsley
Niilo Nieminen	Charles Wright
Karl Olsson	John Wright
Wallace Palazzo	Clifton Young
	Roger W. Young

**TOWN OF
WEST GREENWICH
RHODE ISLAND**

WELCOME HOME

World War II Servicemen and Women

Memorial Day, May 30, 1947

The program from the 1947 Memorial Day ceremony lists the day's activities and also the men and women being honored. It was a major event for the town, continuing a long tradition of recognizing war veterans. Formal recognition of veterans began in 1919, when the town's war monument was dedicated. It is made of local granite from the Tarbox quarry. A plaque, which continues to be updated, lists veterans' names. The monument was originally installed near the Nooseneck Inn and Carr's store, where town council meetings were held at the time. It was moved to the first town hall in 1937, and moved again, in 1970, to the new town hall. The town now holds an annual Memorial Day parade, which concludes with a ceremony at the war memorial. (Both courtesy of the Pysz and Hoxsie families.)

PROGRAM

1:00 P.M. At the Town Hall
Mrs. Cora M. Lamoureux, presiding
Singing, "America"
Invocation - Rev. Wilfred L. Steeves
Greetings from the Town of West Greenwich,
Francis M. Luther, Council President
Vocal Solo
Address - Major Raoul Archambault, Jr.
Awarding of Service Medals - Charles A. Horne and
Mrs. John H. Potter
Community singing, under direction of Leo Gagnon

3:00 P.M. Baseball Game at Nooseneck Hill between the
West Greenwich Atomics and Exeter
In case of rain, games and social hour at the
Town Hall

5:30 P.M. Refreshments and Social hour at the Town Hall

8:30 P.M. Dance at the Town Hall

COMMITTEE

MRS. CORA M. LAMOUREUX - CHARLES A. HORNE
MRS. JOHN H. POTTER

OUR HONOR ROLL

KILLED IN ACTION:

Lester Carpenter	Kenneth Hoxsie
Thomas Healey	Walter Pysz
	Wambola Holm Rabba

DECEASED SINCE DISCHARGE:

Louis Ballou	Richard Moon

William Adams	Eugene Dufour
Clifford Albro	Nathan W. Fellows, Jr.
Henry R. Albro, Jr.	Edwin Fish
Waite Albro	Betty Franklin Altevogt
Wallace Albro	C. Edward Franklin
Everett Andrews	Myron Franklin
John W. Arnold, Jr.	George Greene
John Breene	Harold Greene
Bernice Capwell	Warren Gustafson
George Capwell	Benjamin Hadfield
Joseph Capwell	Frederick Hadfield
Thurston Capwell	Livingstone Hadfield
Donald Card	Robert Hanzlik
Frank Cole	Edward T. Healey
Guy DeMarco, Jr.	John W. Healey, Jr.
Robert Denton	Joseph Healey
Robert Duff	Dean Harrick

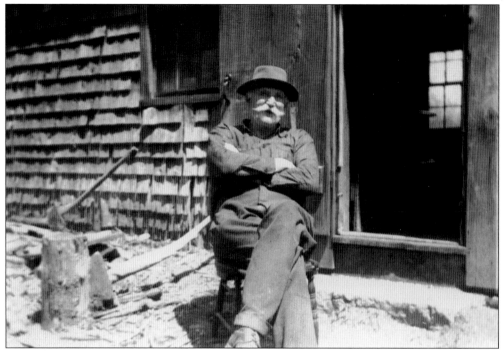

John Tarbox, shown in the photograph from the 1940s or early 1950s, ran the family quarry near Carr's Pond. Tarbox donated the granite for the town war memorial. He was an accomplished weight lifter and served as the personal trainer for 25 young men, who went off to war very physically fit. (Courtesy of Ann Barbour Sundelin.)

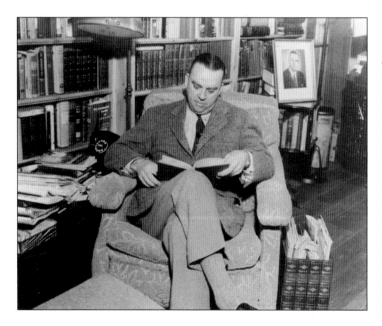

William Easton Louttit Jr. was a businessman and owner of Hianloland Farms. The Louttit family founded the first fire company and built a school to replace one that burned. Through their initiative and funding, the school was later converted to the town library and then moved to its site near the new town hall. Louttit was also an avid book collector. (Courtesy of West Greenwich Historical Preservation Society.)

Howard Barbour, shown in this 1970s photograph, was a woodsman and sawyer. He learned the lumber business while working at Tarbox and Hopkins sawmill and later ran Barbour Lumber Company. Barbour knew the West Greenwich woods and its trees in detail, and he frequently walked miles in them. He lived in a camp near Carr's Pond Road. (Courtesy of West Greenwich Historical Preservation Society.)

Howard Barbour found this odd log floating in Carr's Pond about 1960. It was unusual to find a piece of chestnut because the trees had all died in the blight of 1917 to 1919. The log had an inscription stating that Henry Ford had chopped it on October 24, 1921. An article about Barbour's find appeared in the May 1966 *Yankee* magazine. (Courtesy of Clifton M. Sundelin.)

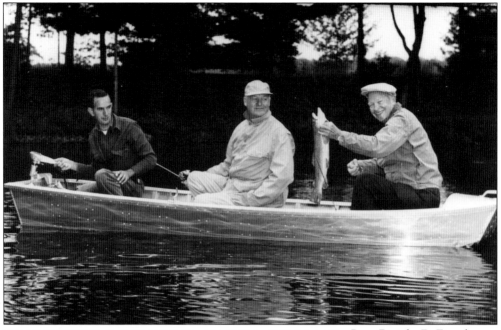

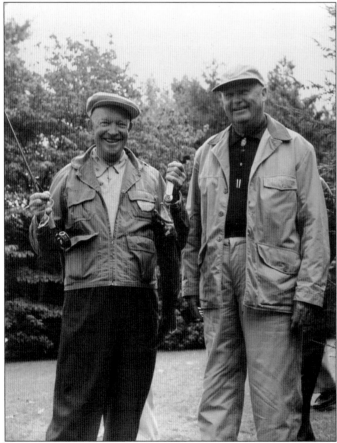

Pres. Dwight D. Eisenhower was a close friend of W. Alton Jones, who purchased Hianloland Farms from the Louttits. Jones, a wealthy businessman, owned several country estates. Eisenhower visited Jones several times at Hianloland Farms, where they enjoyed fishing, shooting, and playing bridge. Eisenhower visited September 13 and 19, 1958, and again on July 9, 1960. These photographs are probably from 1958. Records show he caught 19 fish on those two visits, and he did not fish in 1960. The top photograph shows, from left to right, farm game manager George Wheatley, Jones, and Eisenhower. The photograph below shows Eisenhower and Jones. In both photographs, Eisenhower proudly shows off his catch. (Both courtesy of University of Rhode Island archives.)

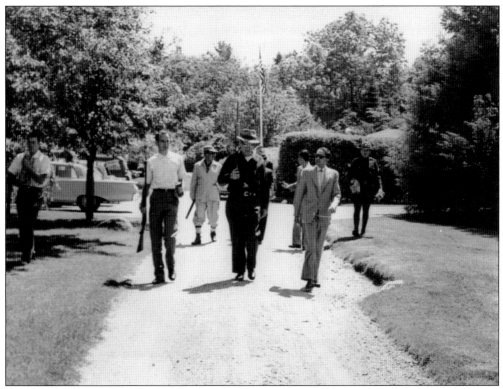

King Mahendra, of Nepal, visited W. Alton Jones at Hianloland Farms. He enjoyed skeet shooting, and Jones installed a special skeet shooting range for his visit. Pictured in the front row, from left to right, are Ernest Harrington, George Wheatley, and King Mahendra. Behind them are several unidentified men, including a guard and a police officer. (Courtesy of West Greenwich Historical Preservation Society.)

W. Alton Jones died tragically in an airplane crash in 1962. His widow, Nettie Marie Jones, donated the estate to the University of Rhode Island. Francis H. Horn, president of the university (left) and Jones are shown raising the flag at the dedication ceremony on April 18, 1965. The university uses the campus for research, environmental education, and conferences. (Courtesy of University of Rhode Island archives.)

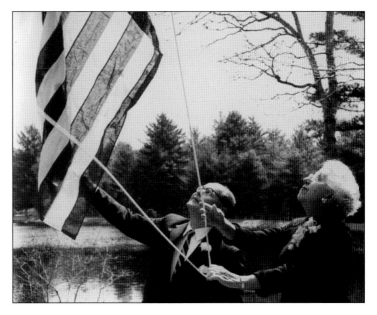

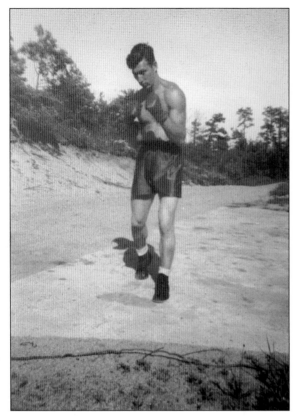

Frank Lemaire was a farmer, logger, and professional lightweight boxer. He fought in regional meets but ended his career when he was needed to work at the farm. In this photograph, he is practicing at the farm in 1947. When Lemaire was in training, he was frequently seen running on the West Greenwich roads, before and after his chores were done. (Courtesy of the Lemaire family.)

James Beattie owned a large lace mill in Coventry and raised racehorses on his farm in West Greenwich. His horses were frequent winners on the local tracks. This photograph shows him in the winner's circle at Narragansett Park on September 8, 1943. From left to right are an unidentified trainer, daughter Joan Beattie, Jim Beattie, daughter Audrey Beattie, brother John Beattie, and an unidentified jockey. (Courtesy of Ann Barbour Sundelin.)

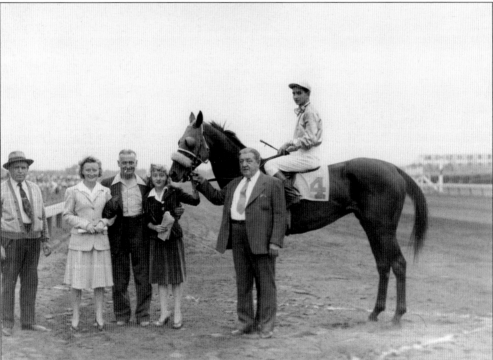

Forest fires were a continual concern of West Greenwich residents. In this photograph, Smokey the Bear is visiting schoolchildren, teaching them about forest fire prevention. He is accompanied by George Matteson Sr., a well-known local forest ranger, historian, photographer, and map-maker. His maps are detailed drawings that include historical locations and interesting facts. (Courtesy of West Greenwich Historical Preservation Society.)

Thomas B. Morris, the proprietor of Liberty Farm, enjoyed making things. He was especially proud of the coffins he made for himself and his wife. They were constructed of well-polished cedar from his farm and were whitewashed inside. He is pictured on October 20, 1900. The coffins stood in their bedroom for 12 years, until they were needed. (Courtesy of West Greenwich Historical Preservation Society.)

From left to right, Florrie May Joslin, Olive Hoxsie, and Laura Joslin are pictured standing outside their little red house in August 1927. Their yard, with its nicely tended display of flowers, contrasts with the reputation of their neighborhood. The house is located in Hell's Half Acre, a stretch of New London Turnpike that bustled with inns and taverns during the peak of stagecoach travel. The area declined rapidly when the turnpike failed, and travelers no longer passed through. The corner that intersected with Congdon Mill Road became notorious and was considered a backwoods red-light district with prostitutes, gambling, and murders. During the height of Prohibition, area speakeasies were frequently raided. The foundations of many of these old taverns can be found in the thick woods. It is good to remember the area was also home to farmers and their families. (Courtesy of the Pysz and Hoxsie families.)

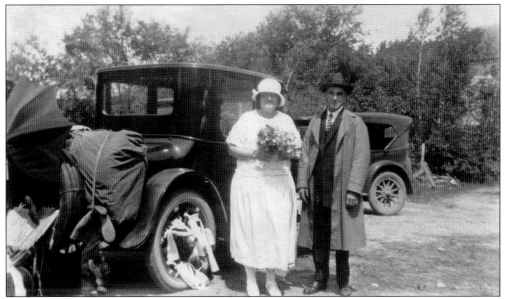

Myrtle and Howard Kettelle were married on August 4, 1924. This photograph shows the couple ready to leave after the wedding. The bride's happy face is partially obscured by her hat. Their car is decorated for the occasion, with white ribbons woven through the wheel spokes. (Courtesy of Colleen [Harrington] Derjue.)

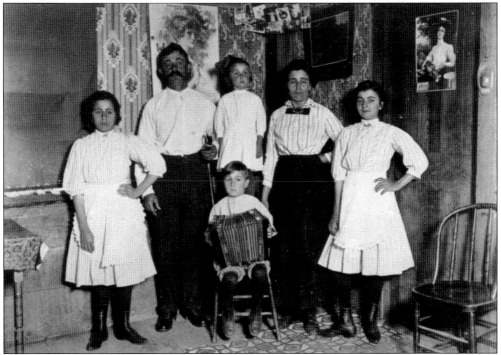

Family portraits can show many different faces and expressions. Photographic equipment of the time required long exposures, especially indoors. It is apparent the children were trying very hard not to move for that long period of time. It must have been very difficult for the boy waiting to play his accordion. (Courtesy of West Greenwich Historical Preservation Society.)

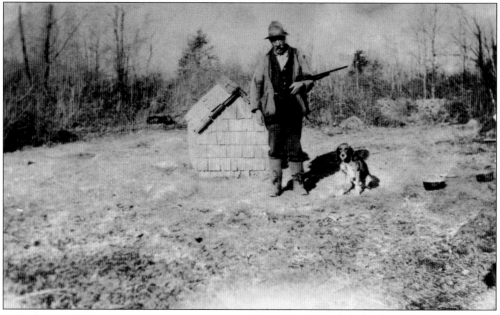

People help their community in many different ways. Henry Goodson, known as "Crook," is shown in this undated photograph with his dog and his gun. Crook taught many local boys how to hunt and shoot. The word *Beausoleuil* is written on the back of the photograph. This may be a translation of Crook's last name or his dog's name. (Courtesy of West Greenwich Historical Preservation Society.)

Charlie Arnold was known for feeding many people in the community. As the chowder man for the Hianloland Fire Company, Arnold is stirring a big vat of simmering clam chowder in this photograph from approximately 1980. The chowder is served with clam cakes at the fire company's spring and fall fundraisers. (Courtesy of West Greenwich Historical Preservation Society.)

This partially obscured face belongs to Russell Franklin. The photograph was taken in the 1920s as he rode in a wagon in the yard of his family's farm. The Franklin family purchased the former Bogman farm on Congdon Mill Road in the early 1900s. (Courtesy of Russell M. Franklin.)

The masked figure in this photograph is Howard Barbour. Barbour is working with a beehive on the Tarbox farm in Hopkins Hill. His gear, including a veil and long gloves, provided protection from potential bee stings. The felled trees provide a reminder that this is a tree farm. (Courtesy of John J. Sundelin.)

Theophilus "Whale" Whaley is believed to have been one of the three regicide judges of Charles I. Whaley fled to America in approximately 1660. He died about 1720. His actual role as a regicide judge remains controversial, but he is considered one of West Greenwich's most infamous residents. His grave is pictured at left. The marker was installed in 1920. (Photograph by Brian R. Swann.)

Brothers Charles and Silas James murdered Joseph G. Clarke. The brothers were hanged for felonious homicide on September 25, 1868. They are referred to as West Greenwich's own James Gang and some people have intimated a connection with Jesse James. There is no evidence of a relation between the families, but the legend lives on. Silas James's grave is pictured. (Photograph by Brian R. Swann.)

Nine

PROGRESS AND PRESERVATION

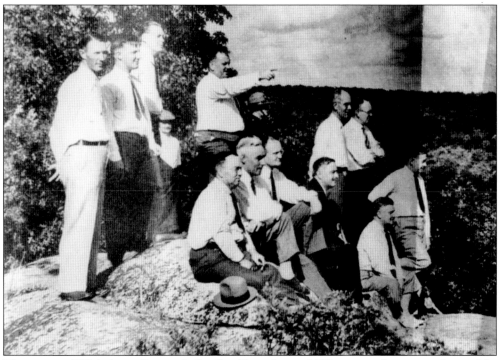

The owner of Wickaboxet Farms, A. Studley Hart, donated 270 acres to the state, to be used for forest demonstration and experimentation. On August 21, 1932, government officials ventured out to Rattlesnake Ledge to view the new acquisition. Hart is in the front row, third from the left. The land is now open to the public for recreational purposes. (Courtesy of West Greenwich Historical Preservation Society.)

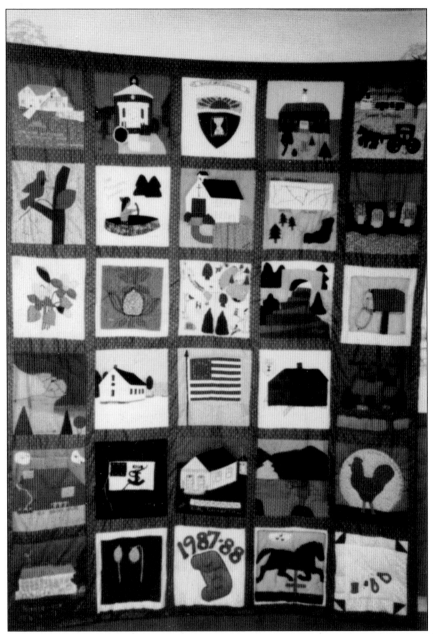

This quilt was made by West Greenwich seniors. It depicts many images and scenes of West Greenwich. The group made two similar quilts. One was made in 1980 for the Heritage Day program and was subsequently raffled off. Another was made later, using the first as a model. The center block in the bottom row was altered to identify this quilt's completion date of 1988. The second quilt, pictured here, is on display in West Greenwich Town Hall Council Chambers. West Greenwich holds various events throughout the year to bring the community together. A highlight is the annual arts and craft show, held on the grounds of the town hall and library. Other events, such as Earth Day and Celebrate West Greenwich, focus on the environment, history, and preservation. The townspeople have a strong commitment to the arts, the environment, and their legacy. (Courtesy of West Greenwich Historical Preservation Society.)

West Greenwich celebrated its 250th anniversary in 1991. Speakers at the celebration included, from left to right, Gov. Bruce Sundlun, town council president Kevin Breene, and president of the 250th anniversary committee Mark Tourgee. Breene later became a state senator and town administrator. Tourgee became president of the town council. (Courtesy of West Greenwich Historical Preservation Society.)

The West Greenwich Happy Seniors created this banner in honor of the town's 250th anniversary. The banner was designed by Trudy March and made by Beatrice Bath, Georgia Long, Marjorie Keefe, and Shirley Hanlon. Town council president Kevin Breene is pictured with some of the ladies at the anniversary celebration. (Courtesy of Kevin A. Breene.)

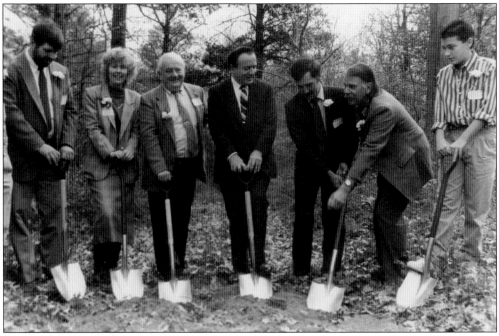

State and town officials gathered on November 5, 1988, to break ground for the new Exeter–West Greenwich junior and senior high school. Wielding shovels are, from left to right, Paul Pierce, Paula Silvia, John Eldridge, Gov. Edward DiPrete, Kevin Breene, William Warner, and Kevin Bicknell. (Courtesy of Exeter-West Greenwich Regional School District.)

The Exeter–West Greenwich junior and senior high school was dedicated on January 26, 1991. It was a state-of-the-art facility that received recognition as the computer showcase of New England secondary schools. A partnership with IBM resulted in computers and a network linking every department and classroom. Cable television studios enabled the students to produce shows to air on the local stations. (Courtesy of Exeter-West Greenwich Regional School District.)

Interstate 95 was built as a major north-to-south highway system in the 1960s. It cut through the eastern end of town and created three exits in West Greenwich. A fourth exit was added in the 1980s. Although some town land was condemned for the project, Interstate 95 brought benefits to West Greenwich. For the first time, residents had an easy route to the northern part of Rhode Island, including the capital city, Providence. This improved access to shopping and events and created a manageable commute. Other people discovered the town, increasing economic activity and the population. The four exits are now the focus of the town's economic development. This photograph shows the southbound exit to Route 3, Nooseneck Hill Road. (Photograph by Brian R. Swann.)

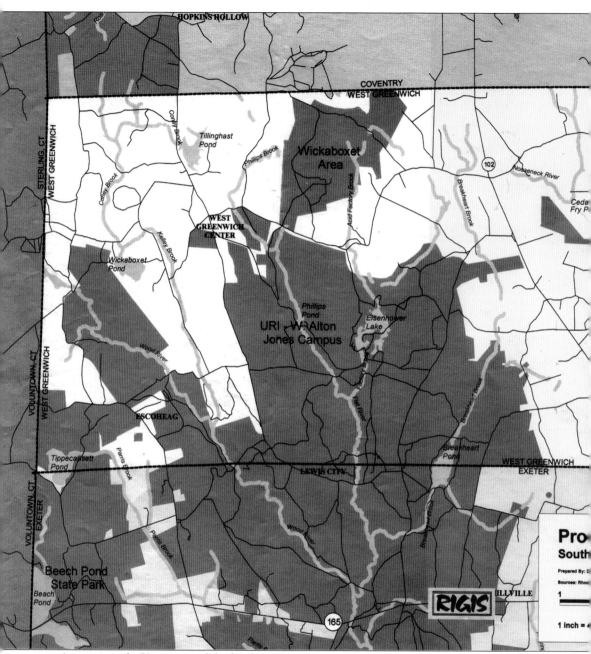

Approximately 50 percent of the land in West Greenwich is protected open space, as shown in this map from 2002. Preserved land includes the Fry Pond Conservation Area (80 acres), the Pratt Conservation Area (56 acres), Arcadia Management Area (14,147 acres, but not all in West Greenwich), Wickaboxet Management Area (670 acres), Big River Management Area (8,600 acres, but not all in West Greenwich), and Tillinghast Pond Management Area (approximately 1,800

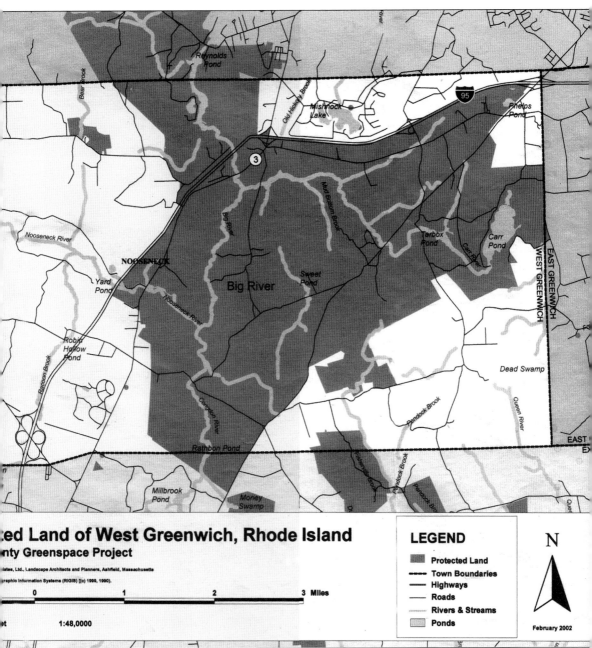

ed Land of West Greenwich, Rhode Island
nty Greenspace Project

iates, Ltd., Landscape Architects and Planners, Ashfield, Massachusetts
raphic Information Systems (RIGIS) [(c) 1999, 1990).

LEGEND

- Protected Land
- Town Boundaries
- Highways
- Roads
- Rivers & Streams
- Ponds

N

0 1 2 3 Miles

t 1:48,0000

February 2002

acres). The Audubon Society of Rhode Island and the Nature Conservancy have open space areas in West Greenwich. There are also numerous land trust arrangements with local families. West Greenwich residents are committed to preserving open space to protect the image and character of the town. (Courtesy of the Town of West Greenwich.)

Between 1965 and 1967, the state condemned 8,600 acres of land to build the Big River Reservoir. This included approximately one-third of the land in West Greenwich. The reservoir has not yet been built, and the land is now designated as open space. There is controversy over land management, but condemnation of this large tract of land also preserved the rural quality of the town. (Photograph by Brian R. Swann.)

In 2006, the residents of West Greenwich approved, in an overwhelming vote, to spend $8 million to purchase and preserve land in the Tillinghast Pond Management Area. This was heralded as an incredible decision for a very small town. The purchase signifies the town's commitment to the environment and maintaining its rural quality of life. (Courtesy of the Town of West Greenwich.)

BIBLIOGRAPHY

Baker, Roberta. *Bits and Pieces of West Greenwich Memoranda.* West Greenwich, RI: self-published, 1976.

Cole, J.R. *History of Washington and Kent Counties, Rhode Island.* New York: W.W. Preston and Company, 1889.

Harpin, Mathias P. *The High Road to Zion.* Pascoag, RI: Harpin's American Heritage Foundation, 1976.

Harpin, Mathias P. and Waite Albro. *In the Shadow of the Trees.* West Warwick, RI: Pawtuxet Valley Preservation and Historical Society, 2003.

Historic and Architectural Resources of West Greenwich, Rhode Island: A Preliminary Report. Providence, RI: Rhode Island Historical Preservation Commission, 1978.

Matteson, George E. *Map of West Greenwich, Rhode Island.* Hope, RI: self-published, 1966, map.

Second Annual Walk & Ride on the Rural Side: A West Greenwich Sampler. West Greenwich, RI: West Greenwich Land Trust, 2003.

Telford, C.J. *Small Sawmill Operator's Manual.* Washington, DC: US Department of Agriculture, 1952.

Walk & Ride on the Wild Side: A West Greenwich Sampler. West Greenwich, RI: West Greenwich Land Trust, 2002.